CHUNG CHANG-SUP
MIND IN MATTER

PKM BOOKS

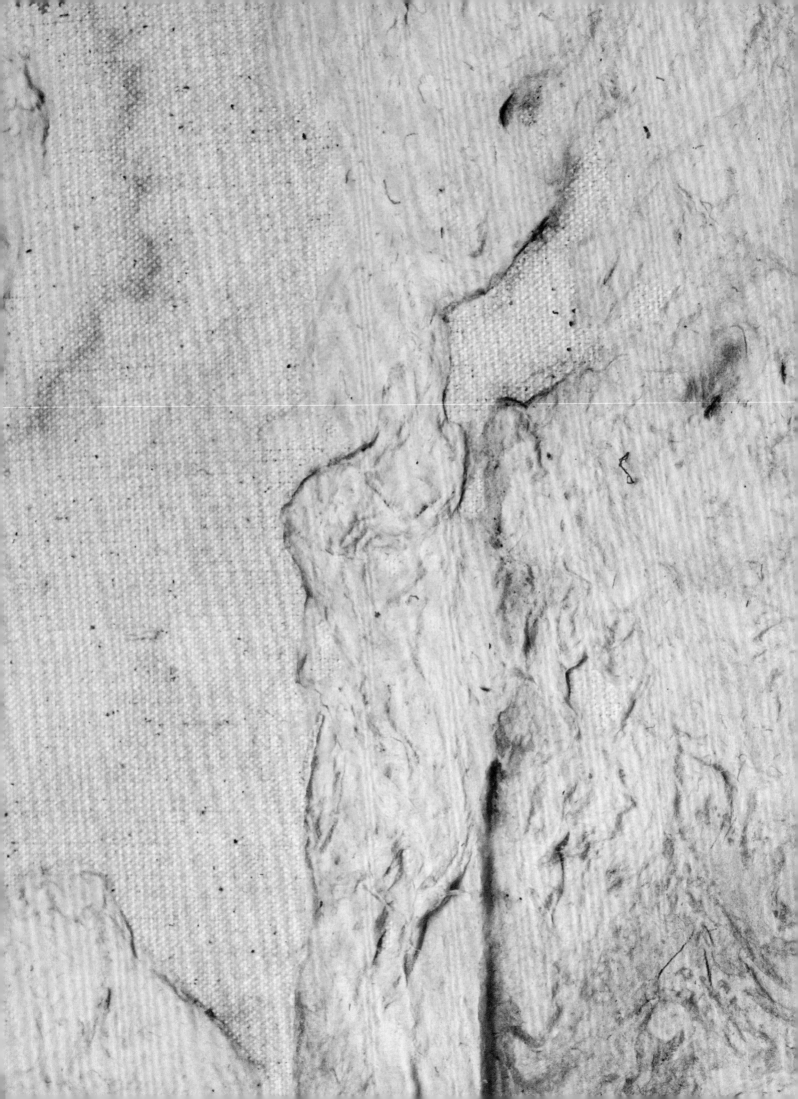

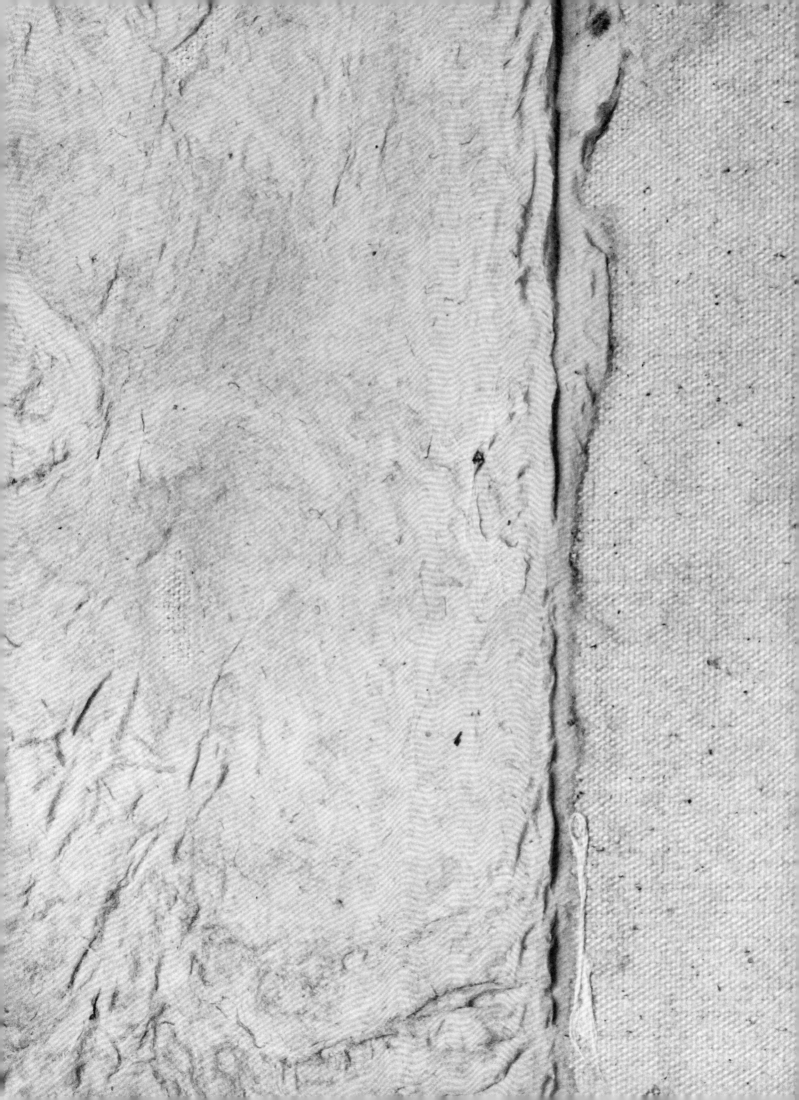

Contents

Chung Chang-Sup

Courtesy of the Estate of Chung Chang-Sup

Meditation

Through *tak**, which is an emblem of our national sensibility, I am expecting my own existence to coalesce with the materiality of the '*tak*.' By controlling the moisture level of the *tak* fiber and paying attention to the trajectory of 'time,' I experience a 'plane' that comes to resemble the surface of granite or the haptic sensation of earthenware.

Instead of unfolding an artificial world that is brimming with intentionality on the surface of an object, I am attempting to adopt the plasticity of a naturalist logic that converges the branches of my consciousness to the material sense that is '*tak*.'

Recently, I have been adding color to *tak*. Even in this process, I am pursuing a state that gently fades and blots as time goes by in a yellowish or blue-gray tone by excluding the artificiality of 'applying' on a surface.

A state of becoming one with the quality of the paper through an embodiment wherein my bodily temperature and smell dissolve—this is what I always aspire after; drawing without endeavoring to draw and creating without endeavoring to create—such is my wish.

Chung Chang-Sup, 1990s

* material made from the inner bark of mulberry tree

Artist Note

According to 'dependency theory,' an 'integration' happens when a value or a phenomenon within a large sphere of influence in terms of culture absorbs or assimilates a different value or phenomenon of a weaker influence.

How can such phenomenon be explained with respect to art culture?

The countless discussions on tradition must have been derived from this conflict.

During this period, I have endeavored to express a new analysis and interpretation of tradition as well as the issue of its inheritance that is fitting for the aesthetic sensibility of the zeitgeist through traces of intellectual consideration and action mainly on the artistic presence of the painting surface. Instead of recognizing the notion of tradition as a value system that is already prescriptively completed inside a certain time-space or as a fixed relic that must be tied by succession under one's ethnic ideology, I tried to understand tradition as a basic catalyst and 'power' that can very much be reconstituted to fit the zeitgeist.

As such, while endowing the surface with autonomy, I allowed for the oriental spirituality and traditional image to naturally seep into the surface in a state that is almost unconscious, excluding my preconstructed notions.

In terms of methodology, I made the non-chromatic elements constitute a potent surface by respecting the more spiritual aspect through *seolchae**, which leaves marks by flowing and blotting, the use of penetrative effect of color and white space, while making the artist's own consciousness clearly encounter the imagistic beauty.

In other words, I attempted a complete comprehension through an organic communication between the self and the world, a reconstitution, and the constitution of a transformative pattern, instead of mainly dealing with the conversation with a fixed object simply because I aspire after a traditional consciousness and a spiritual aspect.

Another thing is that I am carefully watching the dualistic variation and encounter between consciousness and the unconscious, which is the collection and dispersion of a plane that is accidentally chosen and a plane constituted of one's intention and cognition.

Furthermore, amidst such sequence of thoughts, I am paying attention to the 'temporality' as much as to the aspect of meditation and action.

This is because such issue, which clearly could not have met on a conventional and material surface, is capable of converging and restoring behavioral elements to the spiritual level by organically weaving coincidence and destiny, rationality and the irrational, the static and movement, and consciousness and the unconscious.

As such, I am moving forward in a way that attempts to restrain the ornate expression of colors on artworks, overcoming the visual and imagistic obstruction of color through controlling and adjusting thereof by intellect.

Furthermore, I am contemplating a way to express a non-Eurocentric and traditional Korean consciousness and image on a refined aesthetics that is very much within the essence and spirit of contemporary art with ease while avoiding sinking into the feudal and enclosed characteristic that the *xieyi*** taste of traditional Chinese literati may have.

In addition, through my 'drawing' work, I believe I can fully pursue a lucid expression of my mind using pencil line, and thus I am seeking to focus on the works of this genre in the future.

At any rate, I will continue to work on and improve our aesthetic sensibility dissolved within the Korean consciousness through my artwork, thereby expanding and developing thereof, and ultimately arrive at an organic and productive communication with global universality.

Chung Chang-Sup, circa 1982

* layering of ink
** a style of Chinese ink painting

This piece is the draft of "On the Process of Traditional Inheritance Fitting for the Aesthetics of the Zeitgeist" that was published in the 179th volume of *SPACE* in May 1982.

Chung Chang-Sup's Interface of (Real) Color and (Original) Shape
: The Reinvention of Object-Painting Embodying the Spacetime of the Spiritual Medium

0.

The purpose of this article is to find and propose a way to re-encounter and re-think the oeuvre of Chung Chang-Sup (丁昌燮, 1927-2011) from the perspective of the twenty-first century.[1]

In the mid-1970s, when Korea was pushing forward industrialization, the practice and discourse of Korean-style monochrome painting were formulated within the current of resuming exchange between Korea and Japan. It was a period when Koreans developed Yanagi Muneyoshi's Mingei theory into a Korean version. Thus, the so-called Dansaekhwa and the surrounding discourses discovered and reflected on new folk/ethnic traditions from the viewpoint of contemporaries of the industrialization period. The problem is that such thoughts are highlighted and understood today only in its stabilized and complete status, leading many people to overlook the fact that 'the antique abstraction of Informel exists in the basis of Dansaekhwa.'[2] Just as the original members of the Surrealist movement were the Dadaists during and immediately after World War I, the abstract expressionists were actually American surrealists. Robert Rauschenberg created the Neo-Dadaist spacetime by inheriting Marcel Duchamp's Dadaist ideas. By doing so, Rauschenberg could easily overcome the era of Abstract Expressionism.

In the same context, I would like to stress that the essence hidden beneath the surface of Dansaekhwa artists were passionate young artists struggling to find the 'legitimacy of existence' through antique abstraction.

1. Clear Wind and Bright Moon

Modern artist Chung was born in Cheongju, North Chungcheong Province, South Korea. In the cultural area of the Korean Peninsula, those from Chungcheong Province are known for their temperament of being observant and pursuing the middle ground. They do not hasten themselves and easily reveal their thoughts, but they exert decisive influence at important historical moments. It is generally accepted that they are stubborn and ambivalent but not scheming. Heungseon Daewongun compared the people of Chungcheong to a bright moon and clear wind, implying that they have the character of the noble scholar. Within the geographical context of the Korean Peninsula, Chungcheong Province is a midland neighboring a number of different provinces. Thus, it must have been inevitable to learn and inherit the wisdom of reading the current of the times and going with the flow. Chung's life as an artist is just like the bright moon and clear wind, and so are his artworks.

2. Amidst the Current of the Post-war Abstract Art Movement

Born in 1927, Chung belongs to the oldest generation of abstract artists after the Korean War. Many key Dansaekhwa artists were born in the years between 1928 and 1935, and they are the same age as those that laid the foundation for industrialization during the Park Chung-Hee regime. Those that were born before the year 1924 were the first generation of Koreans to be forced to become student soldiers/drafted workers, which gave birth to the phrase "Never ask anything to those born in the year of the Wood Rat." In this generation, it is difficult to find artists with great achievements in any artistic field. For those whose success was measured by their survival, greater misfortunes were waiting for them as they built their families as adults after the liberation and then protected them amid the chaos of the Korean War. (Such misfortunes tended to be passed down to their children and grandchildren.)

Taking this into account, Chung was one of the fortunate ones as he entered the Department of Fine Arts at Seoul National University in 1946. He completed his undergraduate course in 1951 as a student of the inaugural class of the department and stood out as an artist with *Sunset* (1953), a painting he submitted to the 2nd Korean National Art Exhibition and won a special selection in November 1953. Although it must not have been easy to study in the 'refugee capital' of Busan, he could take on a proper role in the uptrend of 'National Reconstruction.' (Prior to the special selection for the National Art Exhibition, Chung organized a 'personal exhibition' at Saetbyeol Dabang [coffee shop] in his hometown Cheongju on August 8, 1953. In 1955, he was awarded a special selection once again at the 4th National Art Exhibition with *Atelier* (1955) [which was incorrectly mentioned as *Interior* in some newspaper articles at the time].[3]) He also developed basic skills as an educator while studying at Cheongju Normal School between 1941 and 1946, which made him a suitable person to lead the art scene as a professor-artist.

'Suhwa' Kim Whanki served as a professor at the College of Art at Seoul National University between 1948 and 1950, which makes Chung as one of the few artists from the university who learned directly from the pioneering generation of abstract art. Yet at the same time, he was also one of Chang Bal's favorite Catholic students. Chang was the inaugural dean of the university's College of Fine Arts and served as a professor from 1946 until 1959. (In 1954, Chung was invited to *Holy Artist Association Exhibition*, which was organized by Chang Bal as a 'Catholic aristocrat.' In 1968, Chung also created a mural for Jeoldusan Martyr's Cathedral.)

When the Rhee Syngman regime was demised by April 19 Revolution in 1960, young abstract painters cried out for the beginning of a new era. However, Jang Meyon–Yun Po-Sun regime failed to stabilize society and the economy. In 1961, when Park Chung-Hee established himself as the Chairman of the Supreme Council for National Reconstruction with May 16 coup d'état, the young generation and majority of citizens supported military intervention in politics. It was the same with abstract artists. In 1961, Suh Se-Ok launched the Rectification (整風) Movement to expel the pro-Japanese factions and concubinage conspirators with the support of the military regime. As a result, senior professors at Seoul National University, including Jang Woo-Sung, were displaced from their positions as of July 29. (On the official record, the date of Jang's resignation is October 22 of the same year.) In the fall semester of 1961, Chung became a newly hired professor with Suh Se-Ok to teach students at Seoul National University's College of Fine Arts in the post-Jang Myeon era.[4] (Chang Bal was the younger brother of Prime Minister Jang Myeon. However, he could not stop Suh Se-Ok's coup d'état reform since he was serving as the acting ambassador of the Republic of Korea to Italy between September 1960 and July 1961 after the April 19 Revolution.)

With his participation in the 1st Contemporary Art Exhibit at Deoksugung Museum, organized by the Chosun Ilbo, Chung was widely recognized as an abstract artist in line with the Informel movement. He submitted his works in every edition of the exhibition except for the 10th, 11th, and 13th edition. (The 11th edition did not take place and the 13th edition was the last exhibition.) His works were always mentioned by art critic Lee Kyung Sung (who was then serving as a professor at Ewha Womans University) in the early years of the Contemporary Art Exhibit when he pointed out specific participating artists and their works in his critical essays.[5] However, as he repeatedly emphasized, Chung was not aligned with the so-called Anti-National Art Exhibition artists.

The leading figures of Korea's post-war abstract art movement were graduates of Hongik University.

After the 'Declaration of Anti-National Art Exhibition' in 1956, they promoted change and growth through group movements including Contemporary Artists Association, Actuelle, and A.G. (Korean Avant-Garde Association). However, Chung did not join any of the groups as an official member. While participating in the Contemporary Art Exhibit, which represented the avant-garde trend, he exhibited relatively consistently at the National Art Exhibition. In addition, he served as a jury member for the National Art Exhibition in 1976. He was also invited to the exhibition in the same year.[6]

In other words, Chung was not the type of artist to disrupt the situation in the midst of controversy, even though he was one of the leading artists at the forefront of the abstract art movement. He was just like a clear wind or a bright moon, always responding to the providence and creating introspective works.

3. From Painting as an Inquiry of Abstraction to Paintings without Painting

With an understanding that Chung's oeuvre has its own autonomy and almost developed out of itself through the artist, one can see that there are six stages of artistic development: The exploration of semi-abstraction in 1954-1956, the experimental period of antique abstraction in the style of Informel in 1957-1965, the medium experiment of ink abstraction and the thematic reduction attempts in 1965-1975, the conversion of the artistic medium through the attachment of *hanji* paper in 1976-1980 (represented by the *Return* series), the brief period of splashed ink abstraction (which developed from ink-and-wash to colored ink technique) after 1980, and the experiments on reinventing *tak*-supports since 1983 (represented by *Tak* and *Meditation* series).

Representatives of Chung's oeuvre are his series since 1983 where he reinvented the supports through *tak* in the state of pulp. Within this general progression, there is also a history of diverse correspondence and adaptation.

In 1983-1984, he explored the 'topography of the plain' by spreading *tak* paper on the canvas and tapping it or groping with his hands in a series entitled *Jeo* (楮). In 1985, he reached the stage of investigating the 'figure of columns' and rethinking the 'combination of planes' through wrinkles in *Tak* (楮) series.[7] It seemed that he was looking back at the period of exploring the overlapping of outlines as part of his early Cubist inquiries. At the same time, it also seemed to be a critical response to the dividing lines of the abstract artist Kim Byung-Ki, who belonged to the generation of *mobo* (Modern Boy).[8]

However, by 1990, the wrinkles disappeared and countless minute movements of the fingers emerged. The emphasis on tactility rather reinforces the sculptural nature of Chung's work, and this necessitates the need to discuss the tactile brushstrokes attempting to correspond to Paul Cézanne's 'truth of painting that depends on the vision of two eyes' and Auguste Rodin's exploration of the tactile surface.[9] In the works created in this period, the memories of abstract-action remained as traces. Therefore, it also seemed that the retrospective works had reached the origin of ruins.

(During the same period, between 1990 and 1991, Chung also tried to create his own version of color field abstraction, which led to another series of works created between 1992 and 1994 where he layered white *tak* over the colored canvas.)

Therefore, Chung's creation of the *Meditation* series in 1993 to employ the critical plane against the reinterpreted pure plane is no less than a silent leap from ground zero of the ruins.[10] From this point on, Chung started extending his square units. By 1994, he reached the complete re-interpretation of post-minimalism. Conveying his meditations on the history of abstract art and his own experiments, he exuded aspects of his late style as an 'outstanding and superb artist.' Through such a late style, the artist revived colors that became one with their support around the years 1995-1996. In 1998, he developed the experiment of soft-edge paintings in response to hard-edge paintings. (The development of canvas as a support with colors went on a hiatus around 1997. Chung reactivated the practice around the years 2001-2003.)

4. From Shape to Color, from Color to Shape, and toward a Meta-interface of Color and Shape beyond the Values of Abstraction

The genealogy of modern art is largely divided into two lines. There are histories of artists that pursue color and ones that pursue shape. In many cases, however, it was the ones that pursue color who created the way out of the existing limitations. Such was the case with the early impressionists who followed Edouard Manet. Barnett Newman, who patiently pioneered the path of post-painterly abstraction against the current of abstract expressionism, was also one of them. However, Cézanne, who was considered one of the post-impressionist painters, examined the issue of shape once again. Through his skeptical overlapping of line drawings and color planes, he presented a great breakthrough in depicting the 'truth of a painter who contemplates on and painting objects.' And this is the reason why we still consider Cézanne as the father of modern art. Cézanne's descendants, or those who aspire to become his descendants, carried out the journey from the issue of color to the issue of shape in their own ways in response to the calling of their times. Henri Matisse took on his part in it, and so did Pablo Picasso.[11]

During the artistic development of abstract art by the post-war generation artists in Korea, Chung neither actively participated nor turned away from the constant struggles, pursuing his own path in peaceful silence. Then, was he an artist of color? Or, was he an artist of shape?

Although Chung seems to follow colorism, he is indeed an artist of academism who reflected on the issue of shape until the very end of his practice. The young artists of the April 19 Revolution generation achieved a triumphant success with antique abstraction, or the Korean Informel. After the mid-1960s, they went through a transitional period of diversity where they tried to extend their medium into experimental art. Around the years 1973-1974, they attempted to turn to the monochromatic method. Then, in the mid-1970s, the dictatorial atmosphere escalated with the approval of the Yushin Constitution. The 'young people who cried out for overthrowing the Rhee Syngman regime' chose to become conservative avant-garde artists who were lost in their inner world.[12] By the mid-1970s, Chung also responded to the task of the era, which was the 'establishment of a methodology to advance self-referential autonomy.' Yet, he had certain exquisite differences from other Dansaekhwa artists.[13]

Since his *Return* series from 1976, Chung began to rethink the pure plane, which was the object to be overcome by a lineage of modern artists from Impressionist painters to Cézanne and to those belonged to Cubism, Blue Rider, Suprematism, and Neo-Plasticism. In the previous period (1968-1975), Chung created stains using the folds of the canvas and produced circular images, experimenting with the specificity of the medium and attempting to exercise reduction on the

level of an artistic theme. The empty yet abundant square-shaped planes in the *Return* series were the intermediate outcome of such reduction. I consider the structure of these meta-canvases as a response to the history of modern art, which has been resisting the pure plane since the Renaissance that resulted in illusionism. In other words, it was a meta-interface to reflect on and contemplate the history of modern art.[14] (If Chung had stopped here, he might have remained as a Korean minimalist artist that had gone through the 'construction and destruction of circular images' and 'devised a rectangular surface-support faithful to materiality.')

In 1983-1984, Chung took on the reinvention of support through *tak* paper with *Jeo* series. In 1985, he further created and explored structures resembling strata of earth with *tak* in the state of pulp with *Tak* series. In essence, he finally succeeded in the complete reinvention of support in the year 1985. At the same time, he also strived to re-investigate the division and combination of planes. In the process, the dividing and overlapping lines of Kim Byung-Ki, an artist of an older generation, were manifested as multi-fold lines between combined planes in Chung's artistic world.[15] During this period, Chung's stratified paintings became sculptural objects in earnest. It can be said that they functioned as a meta-interface to reflect on the growth of the artist himself and his artistic world.

However, with the *Meditation* series from 1993, Chung conceived a stratified painting embedded with critical planes against the pure plane. As a result, in 1994, Chung's meta-interface began to function as an epistemological intermediate-gateway and nodal point to question the agenda of formalism and rethink the conditions for existence of the modern painting.[16] Such a great meta-interface of the artist's late style demands rethinking of the tactile visuality since Cézanne and Rodin. We, who encounter his paintings, are invited to see the subtle movements for a historical leap at the moment we capture the very demand. It is not a movement that one sees with his bodily eyes, but an overarching movement of meta-visuality inferred through the visual, tactile, auditory, olfactory, and gustatory brains when the simulated world in one's brain is activated through perceptual judgement.[17]

Through this meta-interface of his late style in which he employed colors permeating the material of support, Chung overcame the limitations of early minimalist sculptures caused by color field abstraction, which was the problem of ambidexterous paradox. He also showed confidence by presenting his experiments in soft-edge painting as a kind of joke, which was an anachronistic response to hard-edge painting that virtually did not exist in Korea.

In the mid-1970s, Chung returned to his early subject of 'investigating the archetype of the spirit and formative language of the ancient Koreans,' which was also the issue that antique abstraction investigated. Thus, it can be said that he took a different path from other Dansaekhwa artists. Unlike Park Seo-Bo and Yun Hyong-keun, who tried to present the practice of freedom from all ideas and thoughts through, Chung reinvented and developed the Informel's agenda of returning to the imaginary of ancient myth into a meta-interface of return and reflection.

5. The Provisional Conclusion of 2022

All things considered, Chung's meta-interface or object-paintings still remain as 'unfinished tasks' and 'gateways to uncharted territories' that demand re-examination by the artists of today.[18]

Then, what would be the 'legitimacy of existence' that antique abstraction sought to identify? It

was a thinking that the 'lack of legitimacy,' which was prevalent in the academic art formulated through the Joseon Art Exhibition during the Japanese colonial period and the National Art Exhibition as its successor, should be overcome. It was the anger of the April 19 Revolution generation that they had to destroy the authority of Rhee Syngman and liberation aristocrats. And it was also an 'expression of a desperate sense of inferiority' that the artists in South Korea had to establish 'legitimate modernism' against the nationalist socialist realism of North Korean artists. Therefore, it was not until the early 1970s when South Korea's economic power surpassed that of North Korea that South Korean artists could propose the 'way of existence' as a personalized method with a certain collective confidence.[19] Nevertheless, since the mid-1970s, Chung took his own path by returning to the unsolved task of delving into the issue of the 'legitimacy of existence.' As a result, Chung's reinvented abstract painting-object functions as an epistemological portal to reflect on the existential legitimacy of Korean contemporary artists and their art.

Barbara Rose (1936-2020), an art historian who led the minimalism discourse in the 1960s, proposed a new way of understanding abstract art with the term "Abstraction as Identity." Rose speculated that an abstract artist could create a timely and authentic (spacetime of) complexity when he employs diverse heritage of his identity. I would like to redefine her framework as "abstract art that renews and recreates identity," applying it to the Korean post-war contemporary art or Dansaekhwa. At the same time, it would also be possible to re-examine the abstract art and its history in post-colonial regions with regard to the 'overcoming of painting through the process of craft.'

Chung's abstract art was born out of the vulnerability of existential legitimacy that Korea's young generations after the war had to endure. (Even in his early work *Atelier* which displayed a Cubist tendency, Chung questioned himself about his identity as a modernist painter and what he should do in the future.[20]) The Korean society in the 1970s was building its own historical legitimacy. Chung also walked the similar path to other Dansaekhwa artists by pursing a leap from the cultural archetype of the country with confidence. Strangely, however, his meta-interface or object-paintings returned to the initial issues they dealt with.

However, the autonomy of the work always covers values that exceed the 'author's intention.' I think that Chung's meta-interface or object-paintings have already begun to overcome the category of 'modern Koreanness' that he has longed for. It was done through the material of *tak*, which is Asian and shared throughout the world. If Chung's art is to be seen from the perspective of the near future, his works become questions carrying the possibility of 'deconstruction and reconstruction of Koreanness (or Korean modernity).' I wish you to join the journey toward encountering the very questions and looking for their answers.

1) This article aims to overcome the existing interpretations of the artist's works, which employed the 'metaphor of doors (made of *changhoji*)' and the 'synecdoche of doors (applied with *hanji*).' Such interpretations were based on a particular idea of culture as an inherent national characteristic, epitomized by Lee O-Young's logic of cultural exchange between Korea and Japan toward the end of the twentieth century.

2) 'Antique abstraction (古色抽象)' is another name for the Korean Informel movement. The term emphasizes the characteristics of the younger generation of abstract artists after the liberation and the Korean War, who longed to overcome the domination of the so-called 'pro-Japanese liberation aristocrats.' They were inspired by the narratives of the antiquity of the Korean Peninsula (in many cases, the reference point

of antiquity was the Unified Silla Dynasty) and tried to create abstract language or spacetime on the basis of such antiquity. This was also an outcome of the process through which nationalist modernism was seeking its existential legitimacy. (Note: The derogatory term 'liberated aristocrats' occurred since certain Koreans, who occupied elite positions as colonial subalterns during the Japanese colonial rule, rose to the ranks of the Japanese ruling class after Korea's liberation and reigned as a privileged class.)

However, the European abstract art movement also showed a 'tendency to return to the origin and attempt to take on a new start through the reinterpretation of antiquity.' Thus, this is not a particular pattern that is found only in Korea. For example, Matisse materialized and presented Arcadia (Utopia) on the basis of his imagination of antiquity in *Le bonheur de vivre* (1905-1906); Kazimir Malevich declared in his manifesto "From Cubism to Suprematism: The New Realism in Painting" (1915/1916), "Feeling is the determining factor, and thus art arrives at non-objective representation—at Suprematism. It reaches a 'desert' in which nothing can be perceived but feeling. [...] The suprematist square and the forms proceeding out of it can be likened to the primitive marks (symbols) of aboriginal man." Through the observation, Malevich proclaimed a clearer logic of reduction and the will for a new start through his practice.

The tendency toward antique abstraction after the Korean War gradually lost its influence and gave way to the trend of diverse experimental art as the diplomatic relationship between Korea and Japan was restored in 1965 and cultural and artistic exchanges became more prevalent in the mid to late 1960s. Interestingly enough, the key artists of antique abstraction conceived Dansaekhwa as a method around the years between 1973 and 1974. Since 1975, they started following the path of monochromatism in earnest.

3) In 1954, Chung submitted *Onggi Market* (1954) to the 3rd National Art Exhibition, and the work was accepted without the review of jury members. His teacher Kim Whanki made a poignant comment on the work in an essay published in Kyunghyang Shinmun (page 4 of the newspaper on November 7, 1954), "The shape of *onggi* is vaguely embedded in the canvas. I hope that there will be in-depth research on the convergence of abstraction and realistic shapes." *White Porcelain*, a 1956 painting in the collection of the National Museum of Modern and Contemporary Art, Korea, seems to be one of the results he created with Kim's criticism in mind.

4) During the Rectification Movement to drive out the 'liberation aristocrats' after the April 19 Revolution and the May 16 coup d'état, one of the easiest ways was to stigmatize them as 'concubinage conspirators.' Even during the Rhee Syngman regime, many people married at an early age to avoid conscription and married once again after becoming adults and meeting their 'new woman' partners. Many of them remained in double marriage. (Kim Whanki belonged to a rare case of remarriage after a formal divorce.) After the liberation of Korea, many 'new women' in marital relations were accused of being 'concubines of pro-Japanese factions' or 'main culprits of corruption' during the April 19 Revolution and May 16 d'état. Subsequently, they lost their place in the public sphere.

5) Chung's *A Gray Square* (1958) for the inaugural Contemporary Art Exhibit in 1957 was regarded as being "embedded with a visual narrative." In 1958, he submitted *Antique Paint-ing* (1958) to the exhibition. Thus, it seems that he continued the trend of creating antique abstraction. His turn to complete abstraction was through the *Traces of the Mind* series between 1958 and 1961. Afterward, he experimented with thick matière with *All White* (1961), *Work 63* (1963), and *Work 64* (1964), exploring the archetype of ancient Korean beauty as a 'reduction to abstraction.'

6) In 1955, Chung enlisted in the Korean Artists Association, which was established by the Seoul National University clique led by Chang Bal. However, he withdrew from the group in 1961 with Kim Byung-Ki and Suh Seo-Ok.

7) Chung titled his *Tak* series as *Jeo* until around 1986 or later, which was followed by a period in which two names were used at the same time. For the sake of creating a consistent title for the late artist's work, it is necessary to organize different titles in a clear order. With this in mind, this article uses the title *Jeo* for early works in *Tak* series between 1983 and 1984.

8) Between 1954 and 1957, abstract artist Kim Byung-Ki led a class titled "Theory of Modern Art Formation" at Seoul National University's College of Fine Arts. He also took on training courses for senior year students.

9) The poet Rainer Maria Rilke, worked as Rodin's secretary, commented on Rodin's work with an idea of 'inner workings grasped through the surface of objects,' suggesting that the oscillating visual/tactile surface creates a value beyond the simple representation of nature, which means a movement.

10) Since the 16th century when the modern perspective was formulated and developed in Europe, artists began to recognize the interface of painting as a pure surface (reinen Fläche). Accordingly, they began to perceive the interface of sculpture as pure mass (reinen Masse). However, it was only after the 1890s that the significance of the modern perspective was recognized through a new understanding from a critical viewpoint. Painters such as Cézanne were the first to display a meta-critical attitude toward modern perspective. It took approximately two generations to see the emergence of art historians with the corresponding level of awareness.

For example, Heinrich Wölfflin identified the nature of the qualitative transition between the art of the 16th and 17th centuries in *Principles of Art History: The Problem of the Development of Style in Early Modern Art* (1915, Kunstgeschichtliche Grundbegriffe: Das Problem der Stilentwicklung in der neueren Kunst). Erwin Panofsky investigated the historical significance and operational method of the modern perspective in *Perspective as Symbolic Form* (1927, Die Perspektive als "symbolische Form"). In 1929, Alfred Barr Jr. presented the grammar of the white cube exhibition in *Cézanne, Gauguin, Seurat, van Gogh*, which was the inaugural exhibition of the Museum of Modern Art, New York, to reflect on the history of European modern art. All three cases were nothing but the result of assuming the pure plane as a space for meta-reflection in the process of establishing a new understanding of the process of development of modern perspective since the 16th century and its significance. Such an epistemological shift almost immediately gave momentum to modernism, and it led to many achievements of modern art on different scales in different areas.

11) The life of Wassily Kandinsky, considered the father of

abstract art, was also approximate to a process that started from the issue of color and developed into the issue of shape. Minimalist sculptors such as Carl Andre and Richard Serra, who were influenced by the late works of Newman, seized the hegemony at the historical inflection point with their examination of the issue of shape through which they pushed out 'those who started with the issue of color.'

Then, what about Korea, China, or Japan? Kim Whanki started from surrealism in a broader sense, went through a period of inculturating Bauhaus-style constructivism and Kandinsky's synthetism, and eventually found a way to return to the world of colored dots. It can be seen as a progress from the issue of shape and the issue of color. Yoo Youngkuk can be considered an abstract artist who progressed from the abstraction of shape to the abstraction of color. Li Keran started dealing with the issue of light with the impressionist idea and briefly reached a moment of innovation. Yet, he was a painter of shape who synthesized and presented an unprecedented logic of shape in ink painting through multi-perspective images with a cubist concept. On the other hand, Chang Dai-Chien was a master artist who began as an artist of color than shape. His achievement was done through the dissolution of colors in the image. Kazuo Shiraga began with the art of shape and built a field of colors against abstract expressionism. Thus, he also belongs to the color school. Lee Ufan is an artist of shape. To be more specific, he is an artist who has been exploring the reduction of shape in different ways. He also mentioned that he had simple thoughts about the choice of color when he began producing *From Line* and *From Point* series. (both works were presented for the first time in the artist's solo exhibition at Tokyo Gallery in September 1973).

12) In 1960, the Rhee Syngman regime collapsed. At the time, the leading artists of the Informel movement were mostly young artists in their mid twenties and early thirties. However, by the mid-1970s, they were already in their mid to late forties. They were focusing on the method of Dansaekhwa—characterized by the contradictions of the conservative avant-garde—and fell into a paradox of ignoring the social issues of the industrialization period.

13) The history of modern art is marked by the repeated cycle of expansion and reduction, and the issues of color and form have been continuing to generate different aspects to change the situation. Thus, they continue to be intriguing criteria in light of today's condition. The most well-known example of a historical transition is the genealogy of artistic practices from abstract expressionism to minimalism. Abstract expressionism was derived from the surrealist method of unconscious writing, which then gave rise to a tendency to overlap the painterly plane with the visual field. Then, with the rise of agendas related to post-painterly abstraction, there was a transitional period with issues regarding color field paintings. At that time, a group of artists tried to convert color field abstraction into sculpture. As the agenda of primary colors was combined with the agenda of form, the minimalist sculpture of "basic forms" was born with its pursuit of optimizing color and shape. However, with the emergence of true minimalists who pursued the realization of color and shape faithful to the

nature of matter, the agenda of color lost its position in the related discussions. Then, within the development of Korean post-war abstract art, in what ways have the issues of color and shape produced opportunities for transition?

14) It would be very interesting to interpret Chung's meta-interface as a response to Rauschenberg's *Erased de Kooning Drawing* (1953) or Jo Baer's *Untitled* (1964-1972).

15) Among the abstract artists of the post-war generation, those graduated from Seoul National University share similarities. Kwon Young-Woo, Chung, Chung Sang-Hwa, and Youn Myeung-Ro devoted themselves to the construction of a formative language through overlapping lines. The exploration of the logic of abstract art through the 'exercise of skeptical and hesitant lines' after Cézanne shows an interesting contrast to the so-called Hongik University clique of Yun Hyong-keun, Park Seo-Bo, and Ha Chong-Hyun who yielded unconstrained lines. (On the other hand, younger generation artists from the Seoul National University clique, such as Lee Kang-So and Kim Ho-Deuk, showed different characteristics. They exercised one-stroke lines that could be understood as images through the optimized process of abstract actions.)

16) This transition was realized in 1993, the same year Chung retired from the professorship.

17) When you scan Chung's work as if you were the artist using his eyes and hands to feel the surface of the painting, or when you see Chung's work with your eyes closed like the critic Shigeo Chiba, you will feel the sound, smell, and taste at the same time.

18) Steve Jobs frequently cited Alan Kay, a figure who greatly contributed to the process of creating the multimedia space-time by proposing a computing interface. "People who are serious about software should make their own hardware." The same applies to the methodological turn in the Korean post-war abstract art.

19) Modernist art in Korea was developed as a 'project to build legitimacy for the modern spacetime to exist.' Therefore, abstract artists could participate in the 'people's documentary paintings' projects without hesitation. (In August 1977, as the documentary painting project had reached its limit, a research trip to Southeast Asia was organized with five artists as a way to find new possibilities. Along with Chung, Kim Tae, Choi Dae-Sup, Moon Hak Jin, and Lee Jong-Sang participated in the trip. Unlike the way people's documentary paintings had been manufactured by twenty artists, the research trip commissioned in-depth works by the five artists.)

20) With the emergence of Cubism, painters at the Salon de la Section d'Or tried to succeed and overcome Georges Braque and Picasso, who responded to Cézanne's outline, using lines that overlapped, misaligned, and divided. From the viewpoint of those that came after them, the core of the issue is not just about the geometrical simplification. The key is how to acquire the analytical modernist's perspective on the subject and the method of synthesizing the process on the canvas.

Lee Chungwoo (Lim Michael)
Art and Design History/Theory Researcher

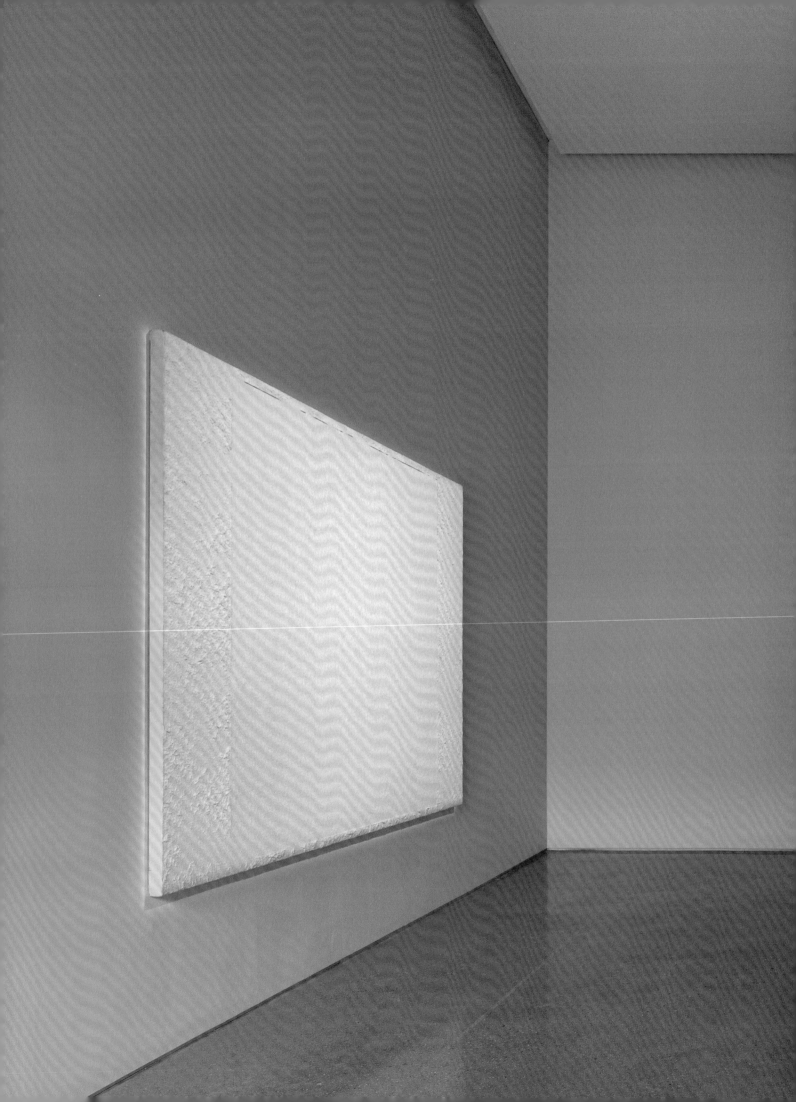

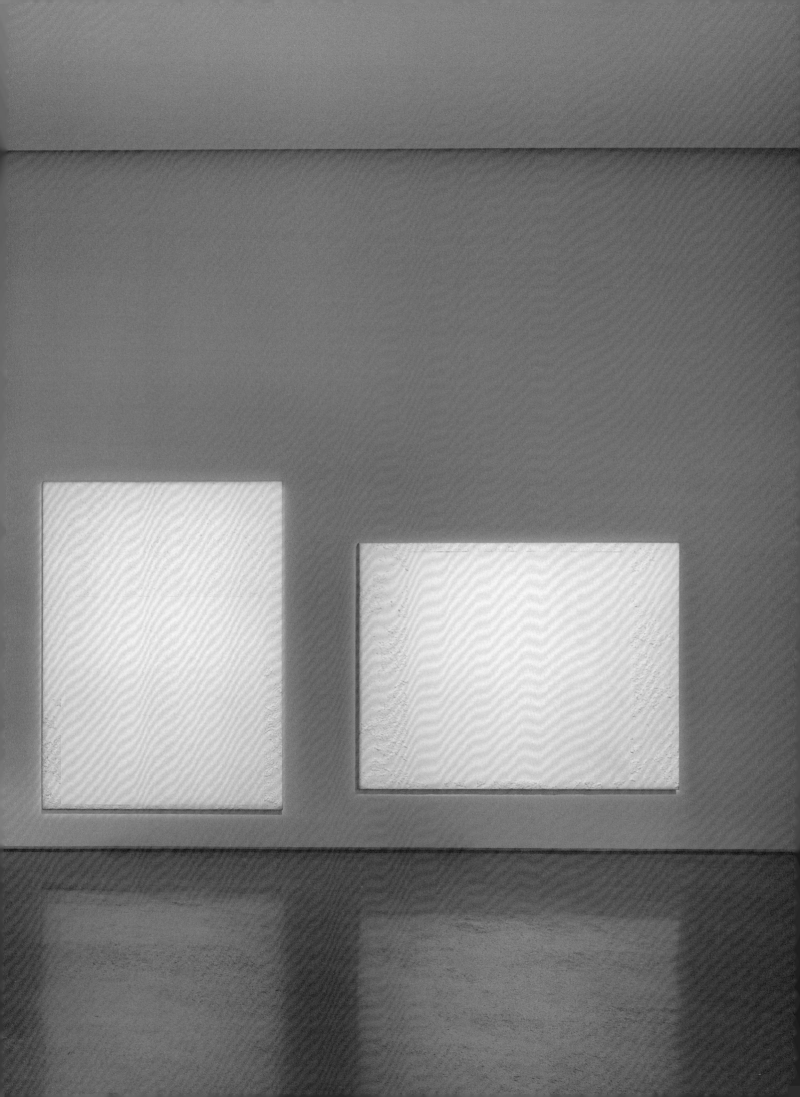

01. Meditation 20112, 2000, Tak fiber on cotton, 259 x 194 cm

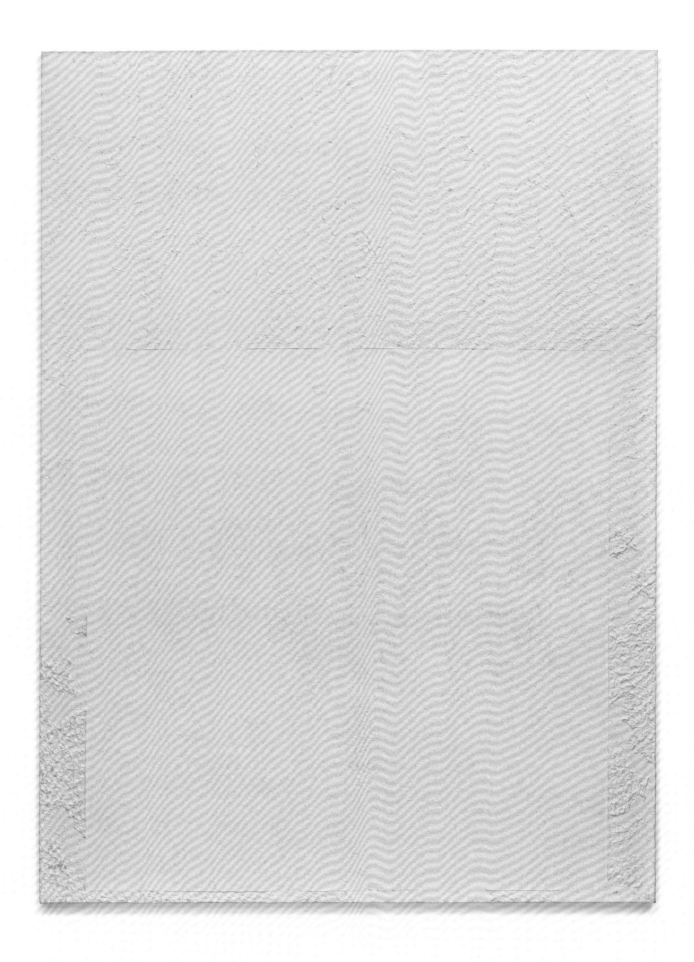

02. Meditation 20301, 2000, Tak fiber on cotton, 194 x 259 cm

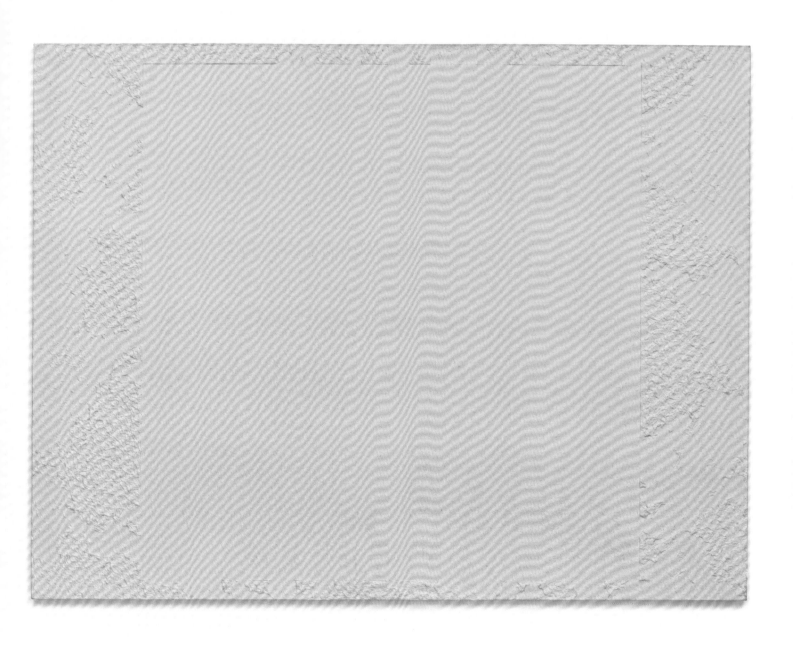

03. Meditation 94705, 1994, Tak fiber on cotton, 220 x 140 cm

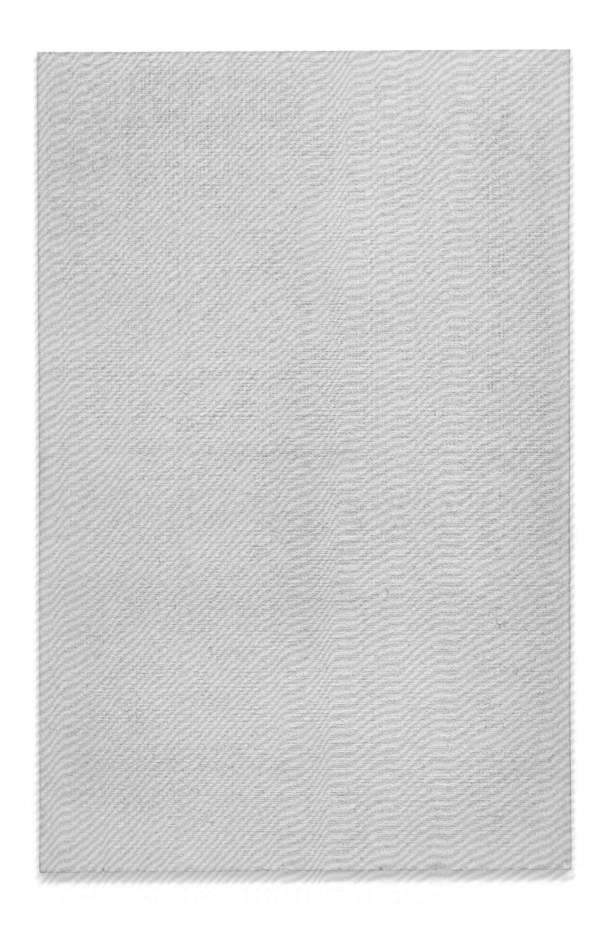

04. Meditation 22806, 2002, Tak fiber on cotton, 130 x 162 cm

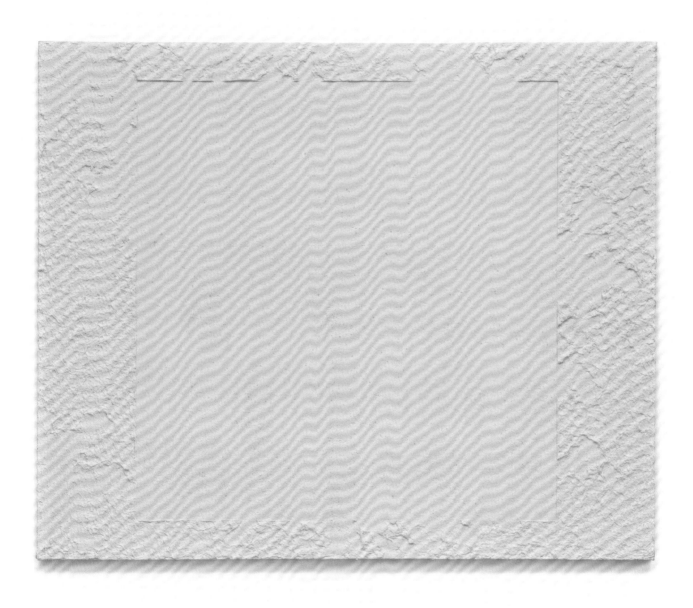

05. Meditation 981005, 1998, Tak fiber on cotton, 194 x 259 cm

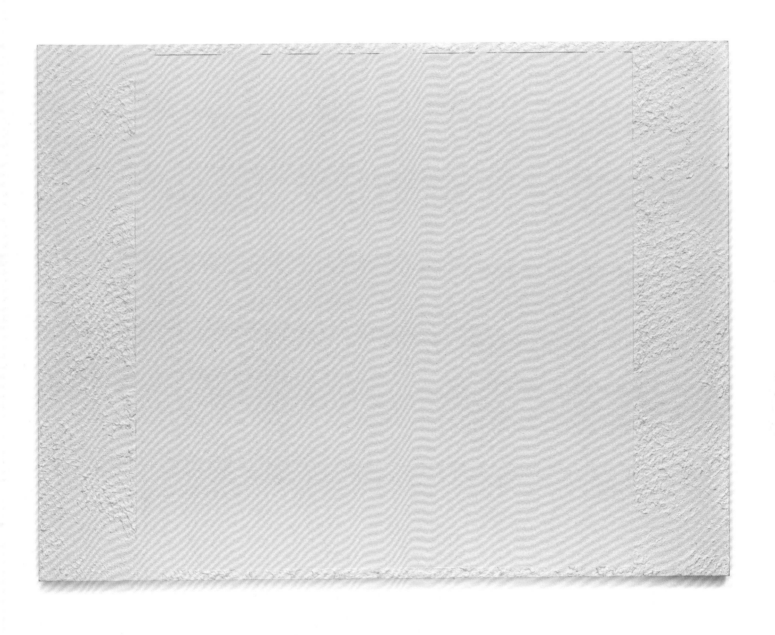

06. Meditation 211204, 2001, Tak fiber on cotton, 194 x 259 cm

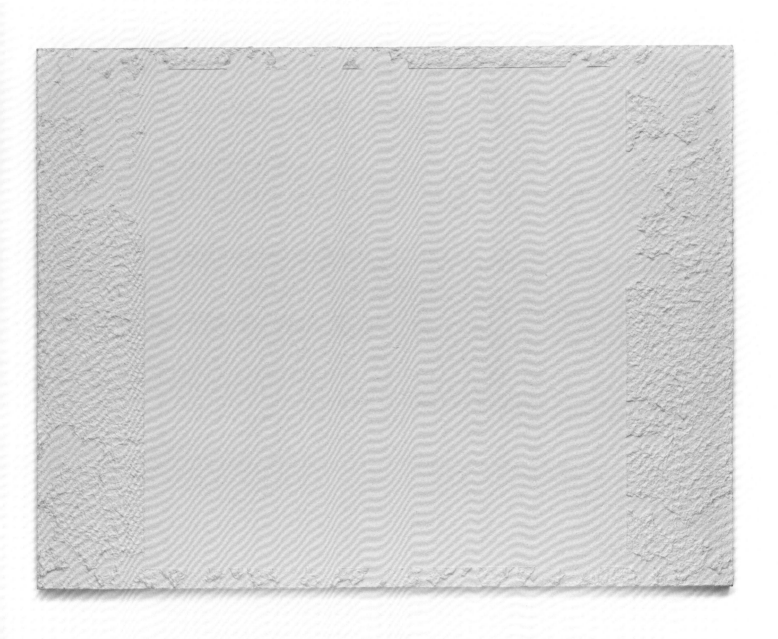

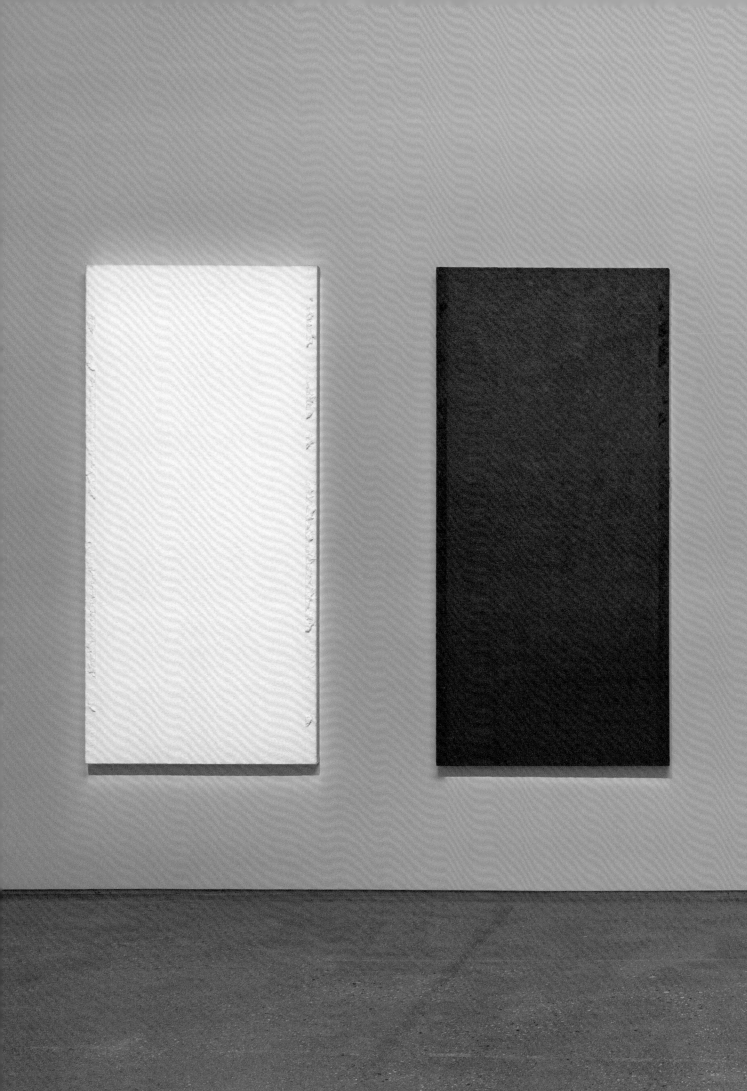

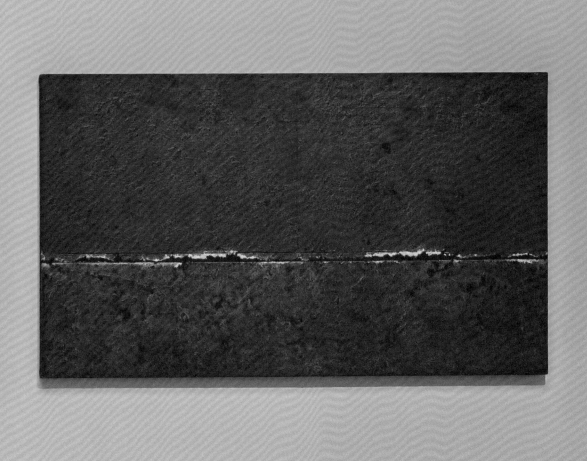

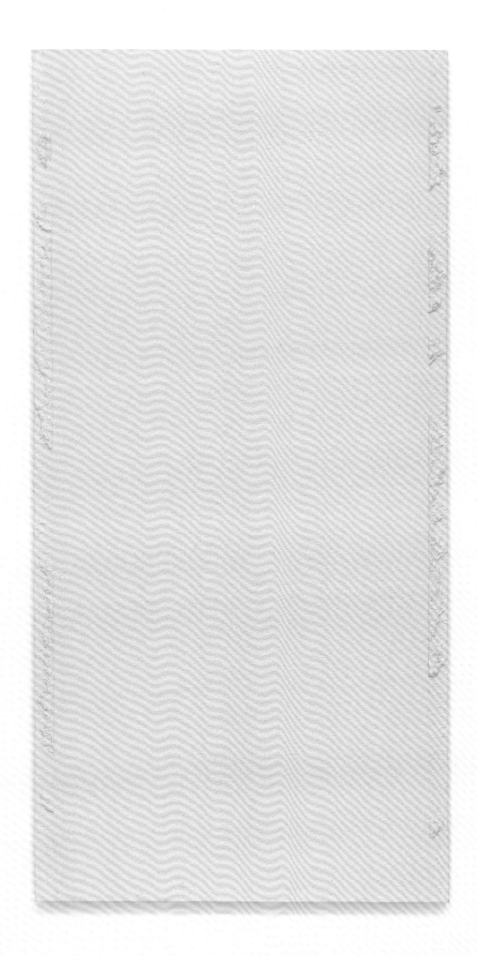

07. Meditation 23904, 2003, Tak fiber on cotton, 180 x 90 cm

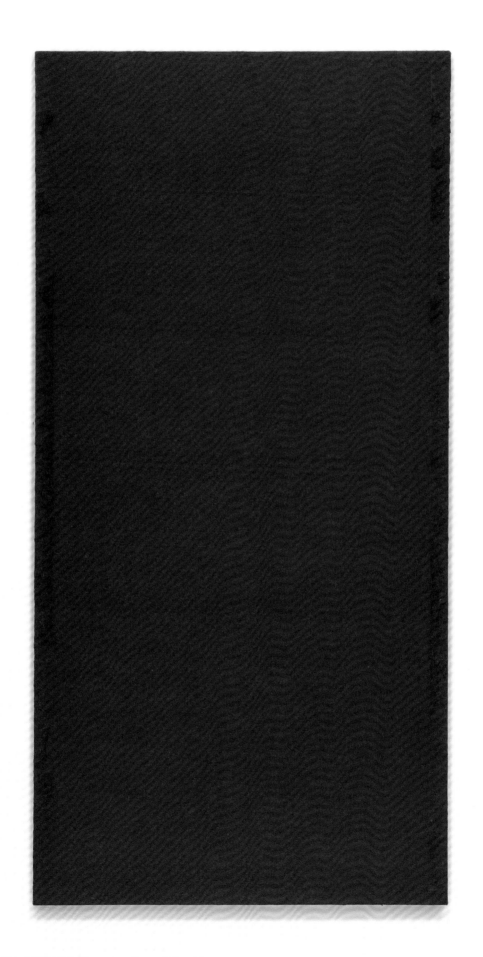

08. Meditation 23901, 2003, Tak fiber on cotton, 180 x 90 cm

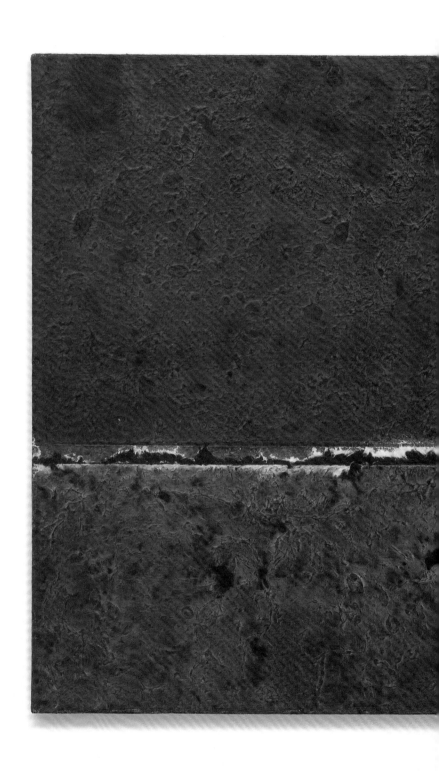

09. Meditation 91101, 1991, Mixed media with Korean paper, 110 x 200 cm

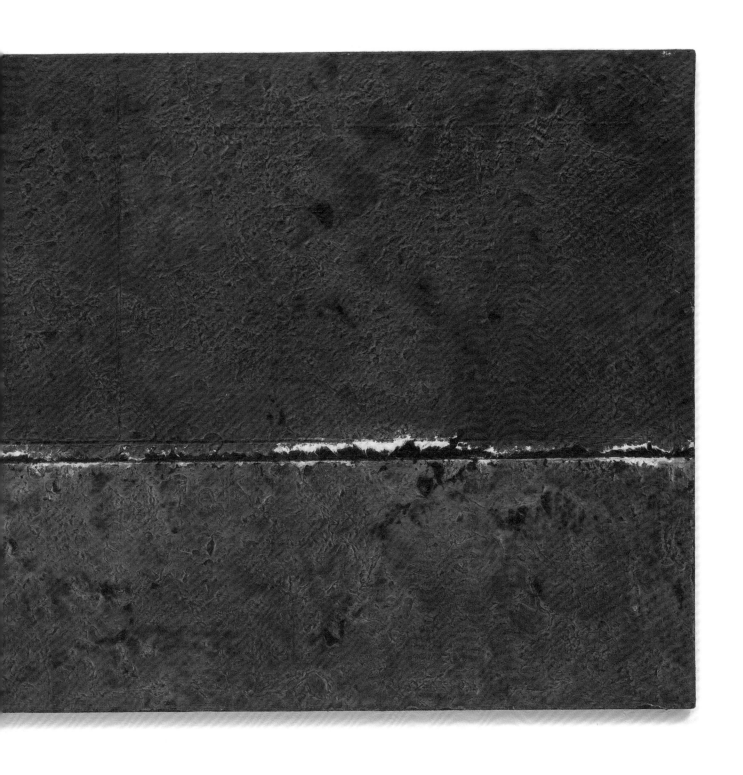

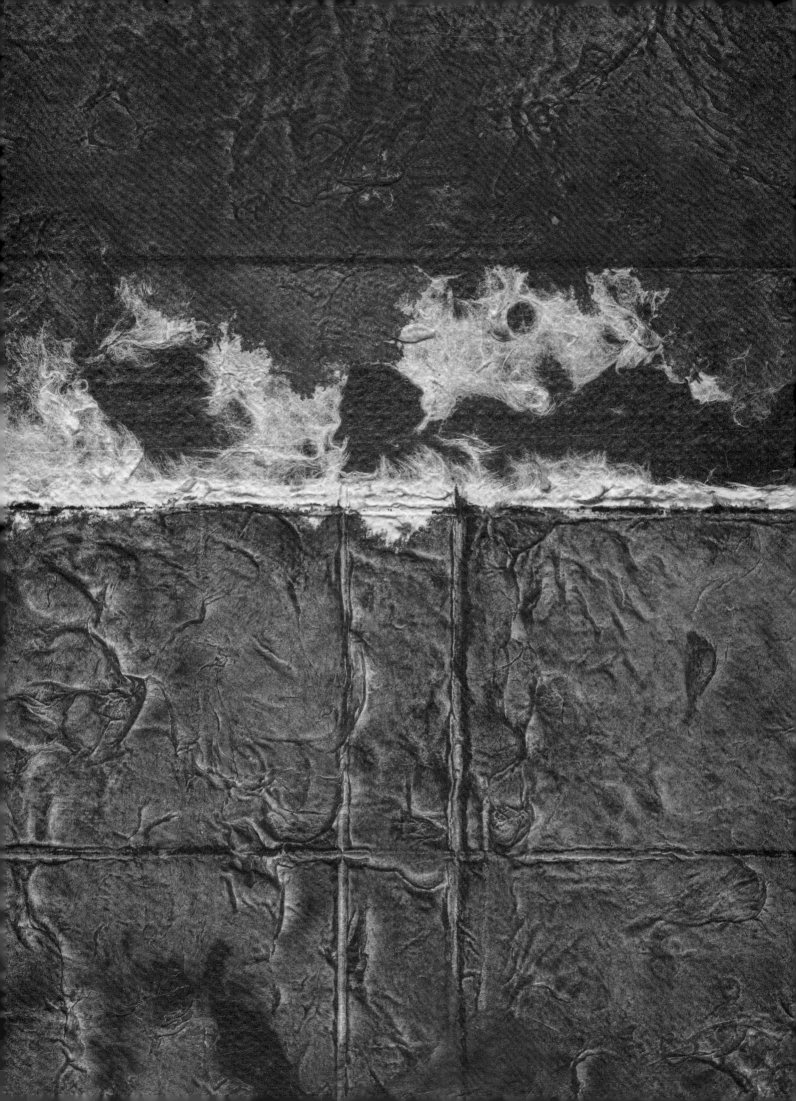

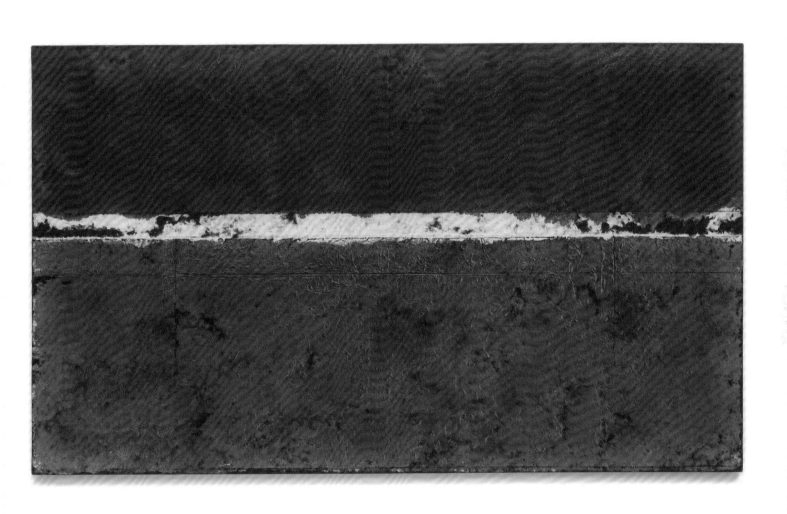

10. Meditation 91077, 1991, Tak fiber on canvas, 140 x 240 cm

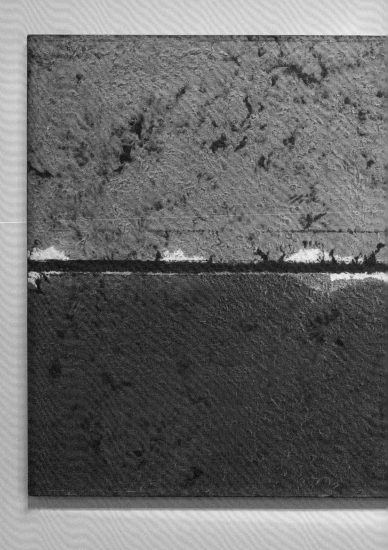

11. Meditation 91216, 1991, Tak fiber on canvas, 140 x 240 cm

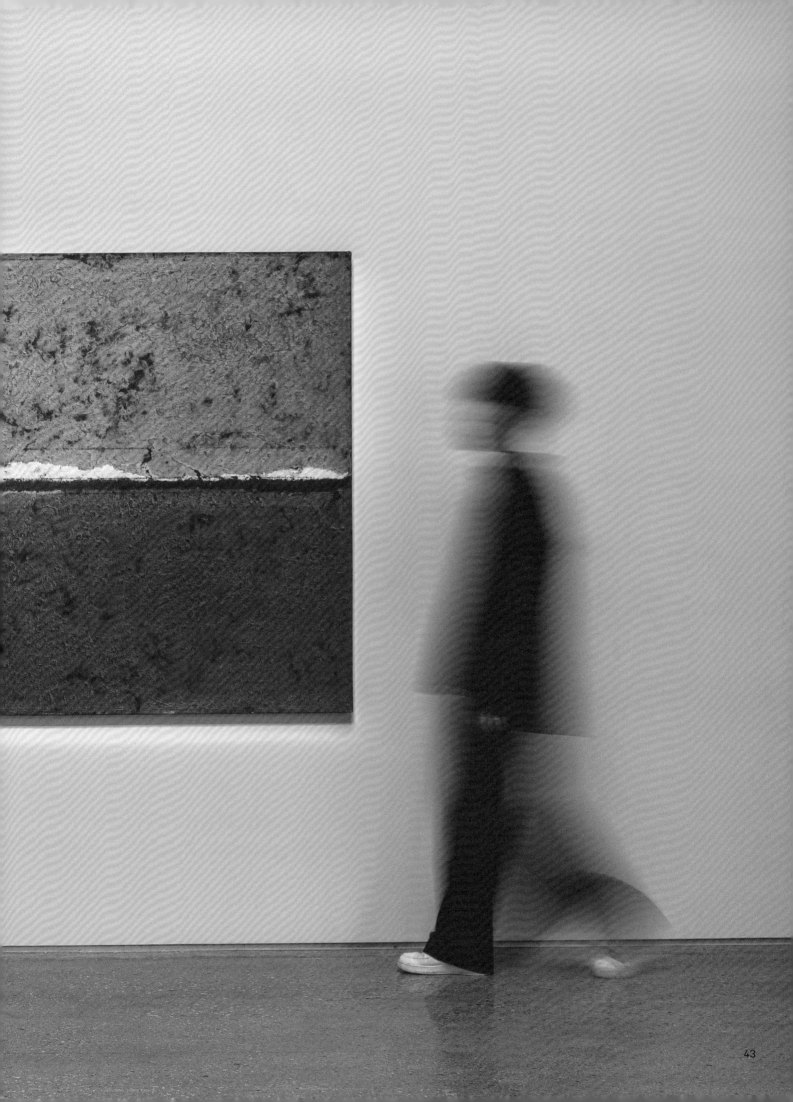

12. Meditation 97620, 1997, Tak fiber on cotton, 97 x 130.3 cm

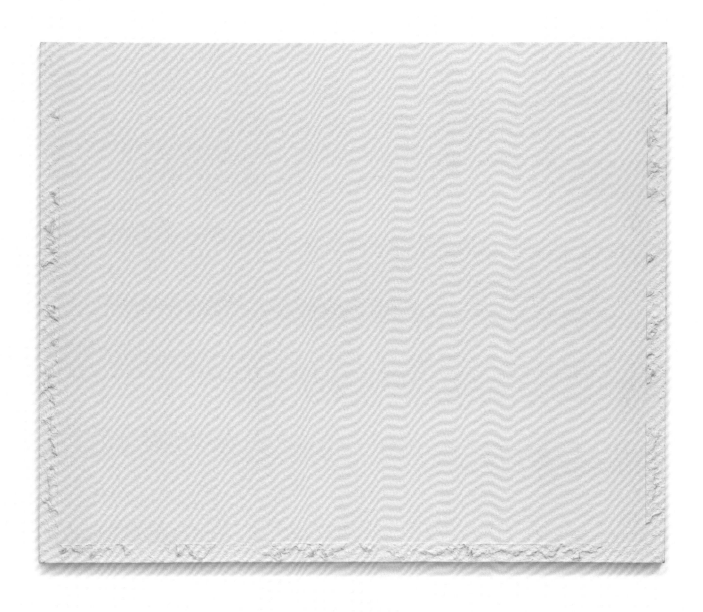

13. Meditation 22903, 2002, Tak fiber on cotton, 130 x 162 cm

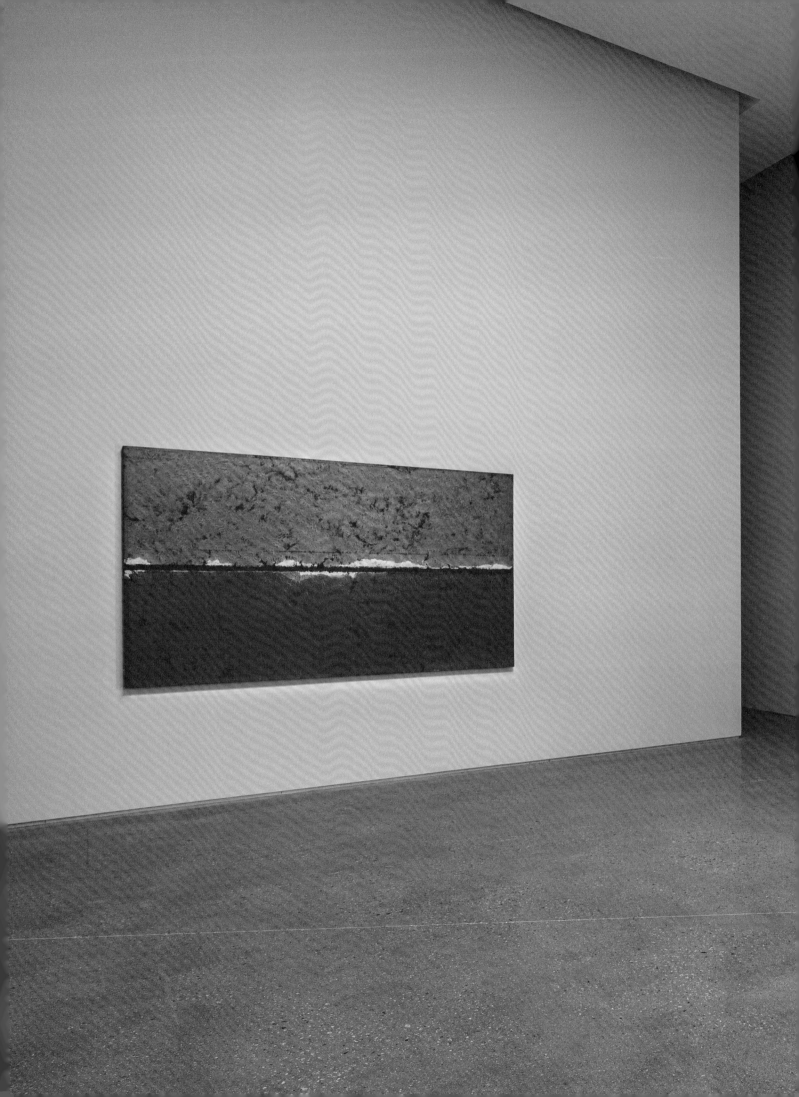

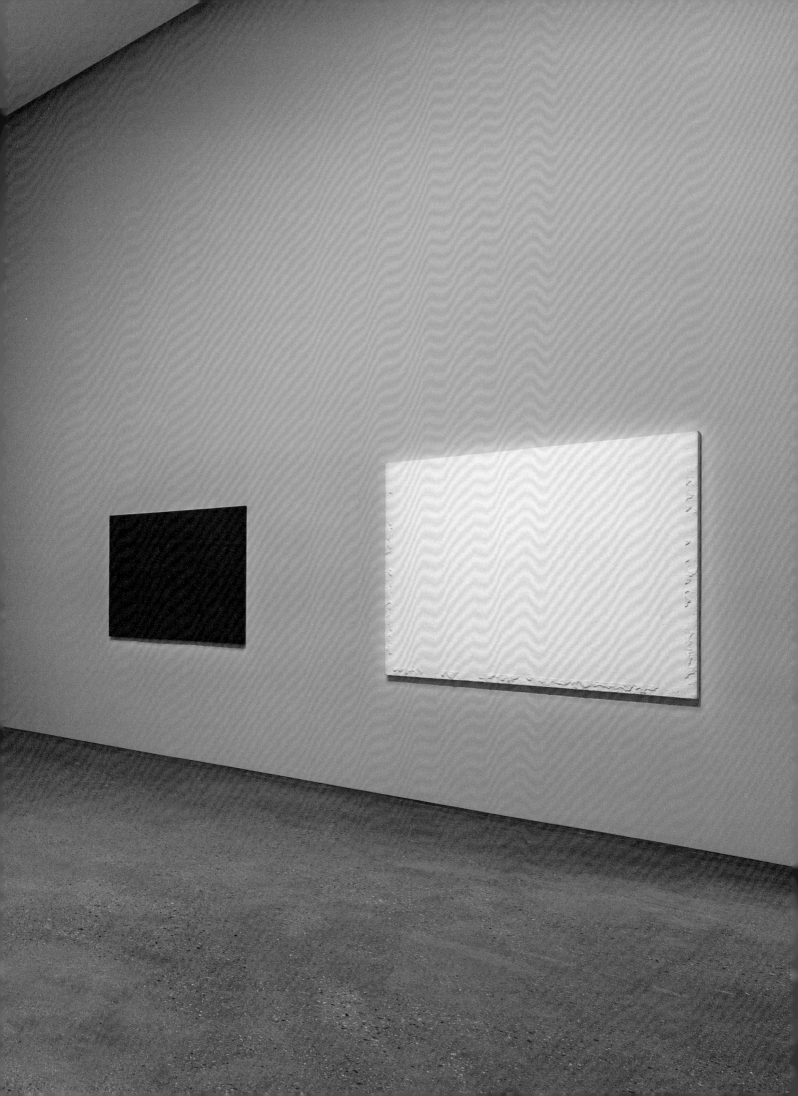

14. Tak 88002, 1988, Tak fiber on cotton, 97.2 x 130.5 cm

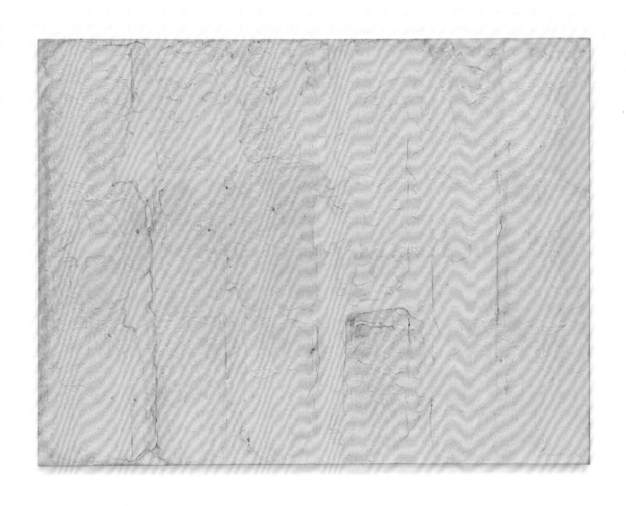

15. Untitled, ca. 1991, Tak fiber on canvas, 73 x 91 cm

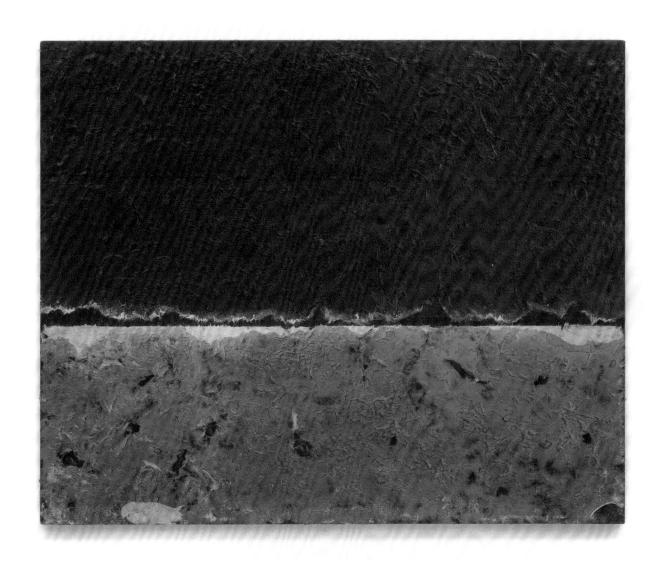

15. Untitled (detail), ca. 1991, Tak fiber on canvas, 73 x 91 cm

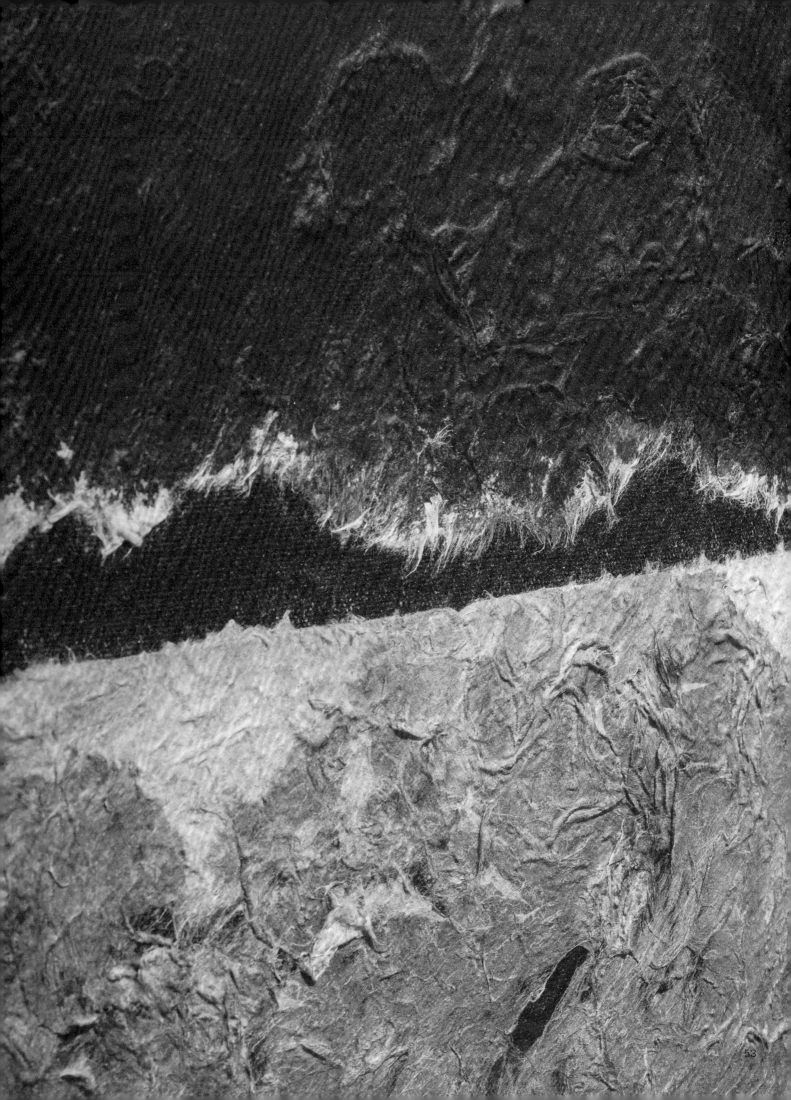

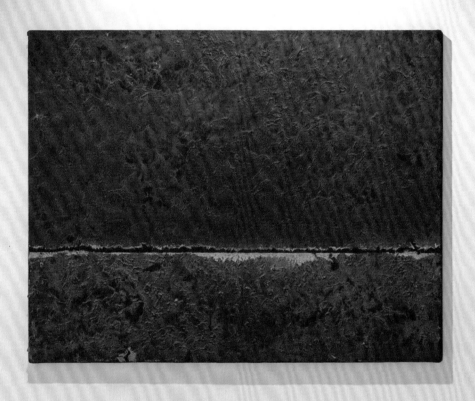

16. Untitled, ca. 1991, Tak fiber on canvas, 92 x 116 cm

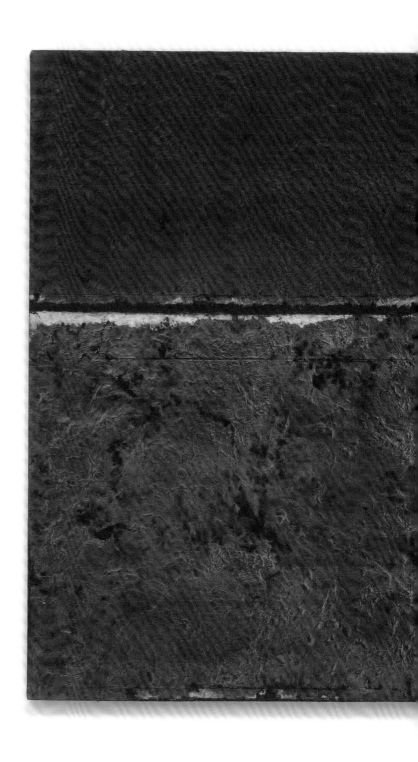

17. Meditation 91107, 1991, Mixed media with Korean paper, 110 x 200 cm

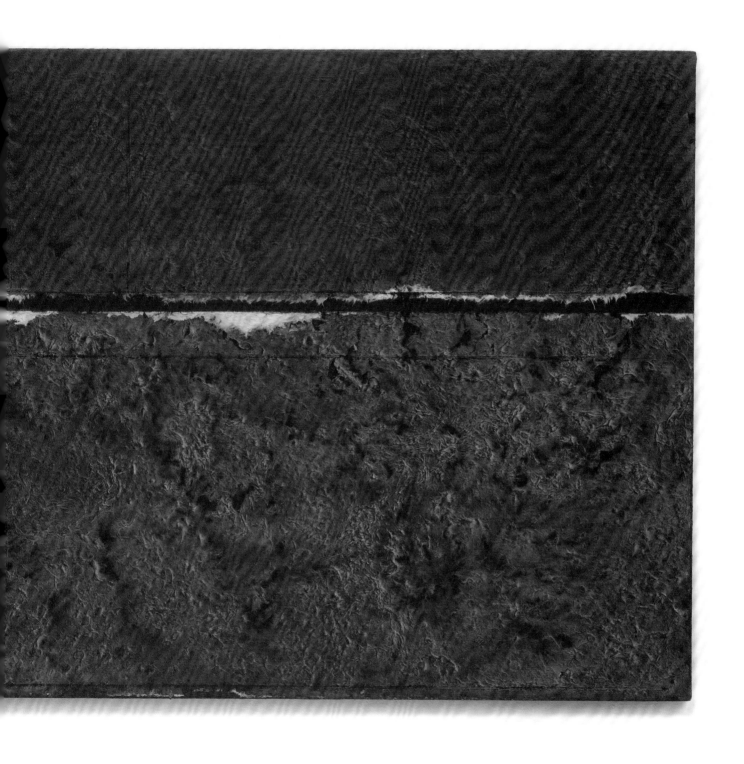

18. Meditation 20810, 2000, Tak fiber on cotton, 60.6 x 72.7 cm

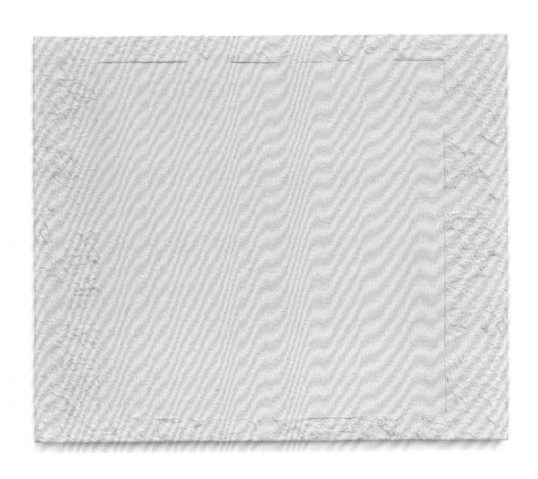

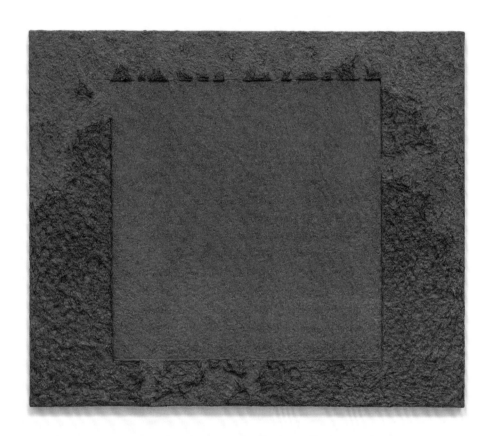

19. Meditation 21804, 2001, Tak fiber on cotton, 60.6 x 72.7 cm

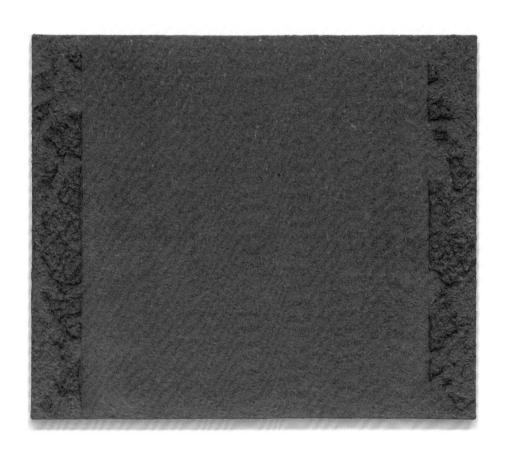

20. Meditation 21805, 2001, Tak fiber on cotton, 60.6 x 72.7 cm

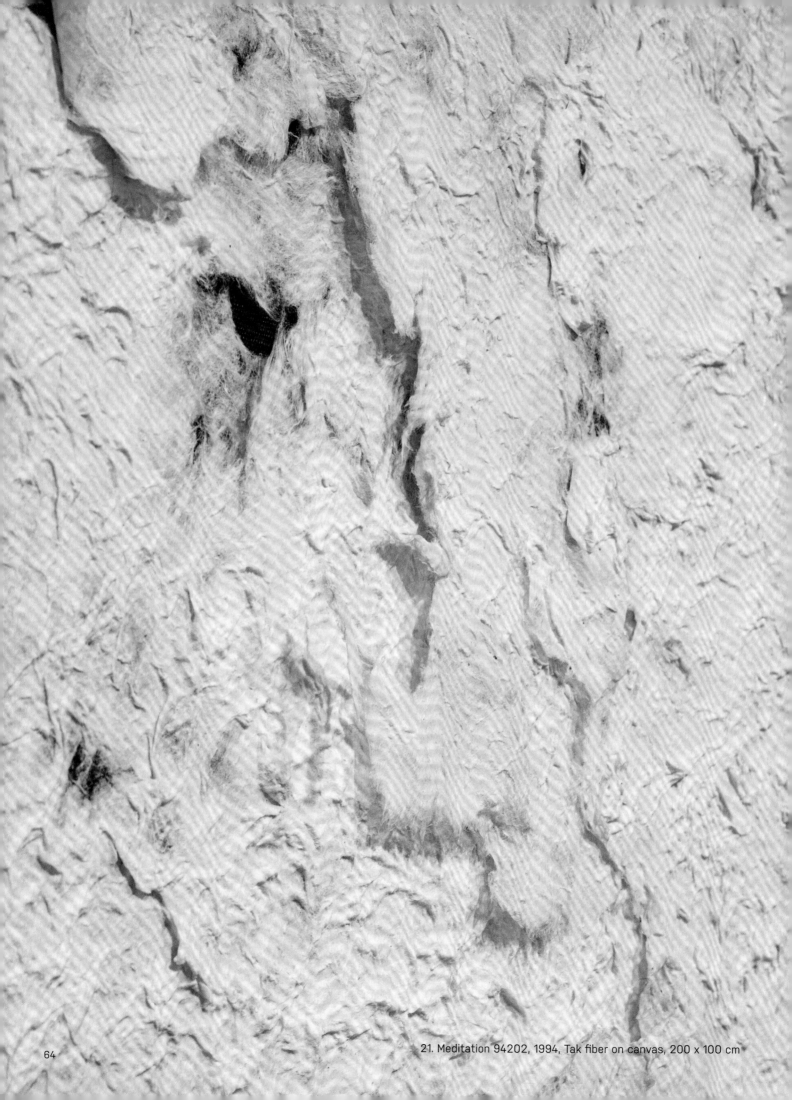

21. Meditation 94202, 1994, Tak fiber on canvas, 200 x 100 cm

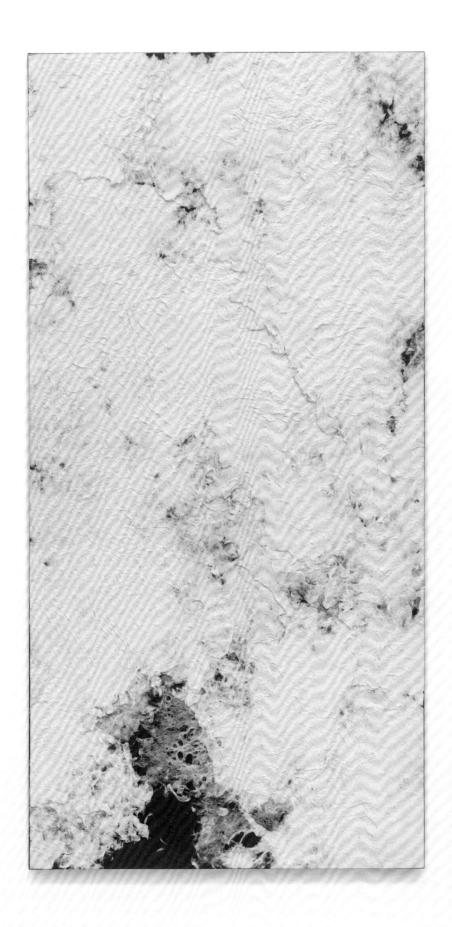

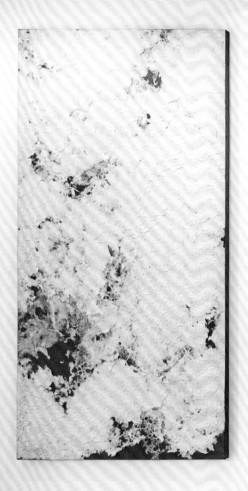
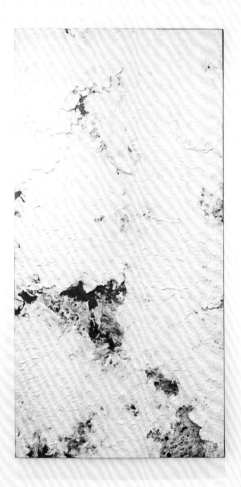

from left. 22. Meditation 94203, 1994, Tak fiber on canvas, 200 x 100 cm
23. Meditation 94201, 1994, Tak fiber on canvas, 200 x 100 cm

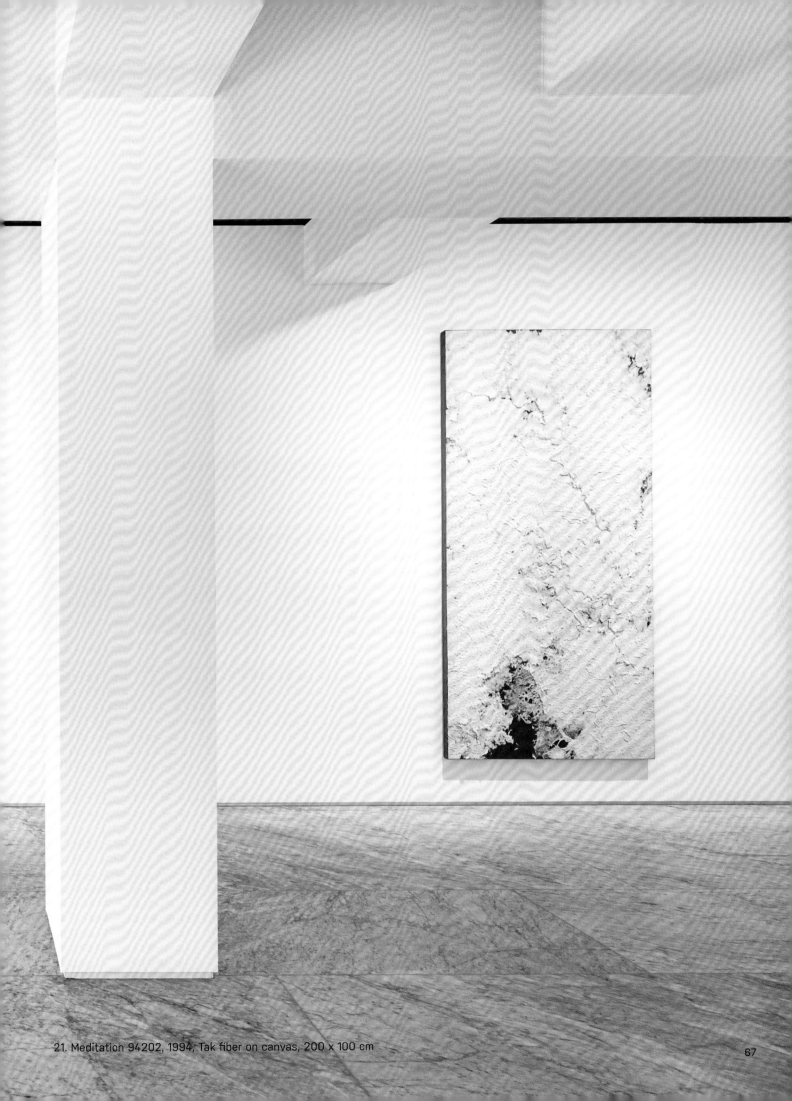

21. Meditation 94202, 1994; Tak fiber on canvas, 200 x 100 cm

24. Meditation 21206, 2001, Tak fiber on cotton, 130 x 162 cm

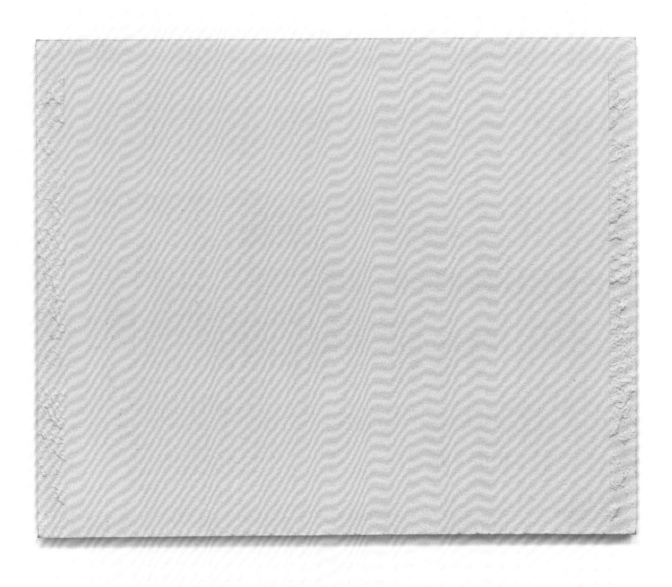

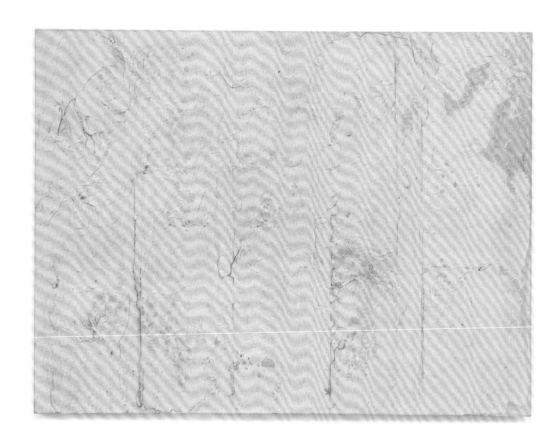

25. Tak 88001, 1988, Tak fiber on cotton, 97.2 x 130.5 cm

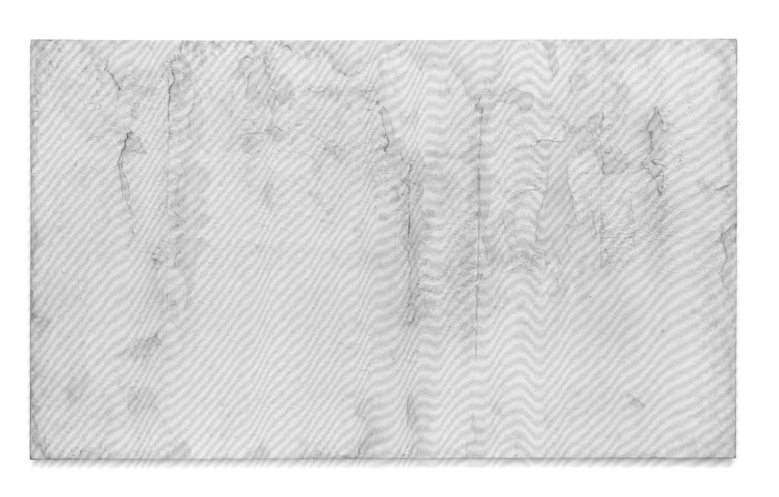

26. Tak 89033, 1989, Tak fiber on cotton, 120 x 210 cm

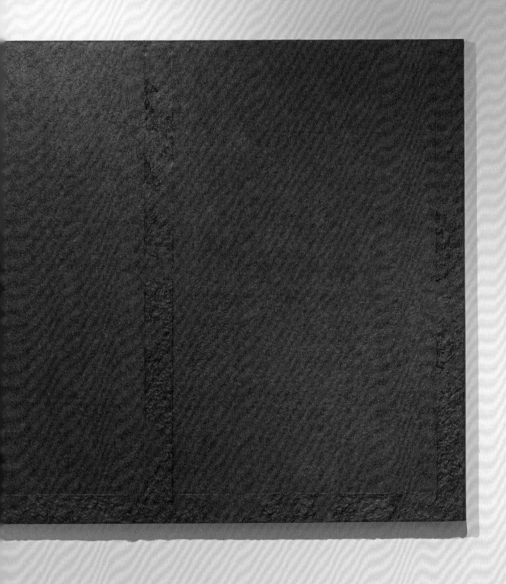

27. Meditation 971041, 1997, Tak fiber on cotton, 100 x 130.3 cm

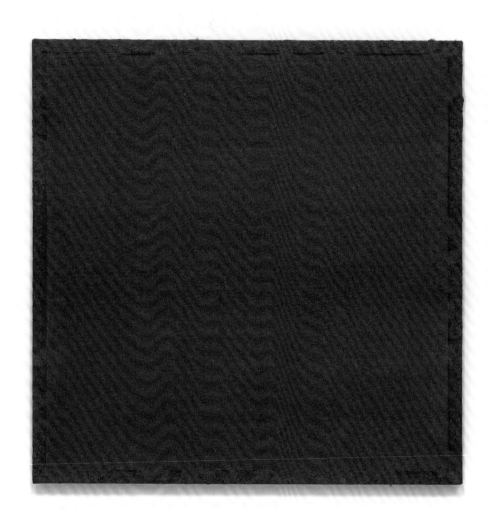

28. Meditation 98705, 1998, Tak fiber on cotton, 80 x 80 cm

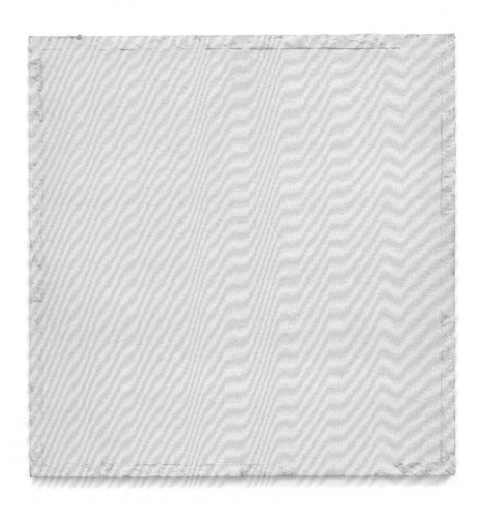

29. Meditation 98702, 1998, Tak fiber on cotton, 80 x 80 cm

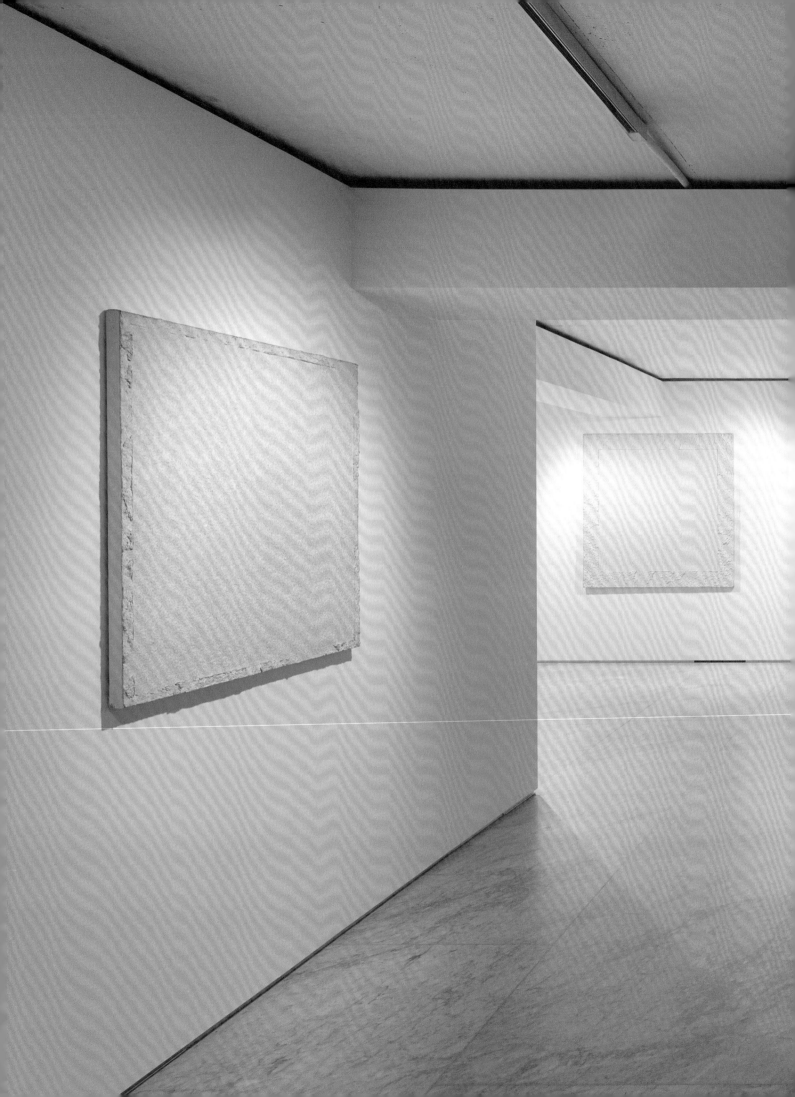

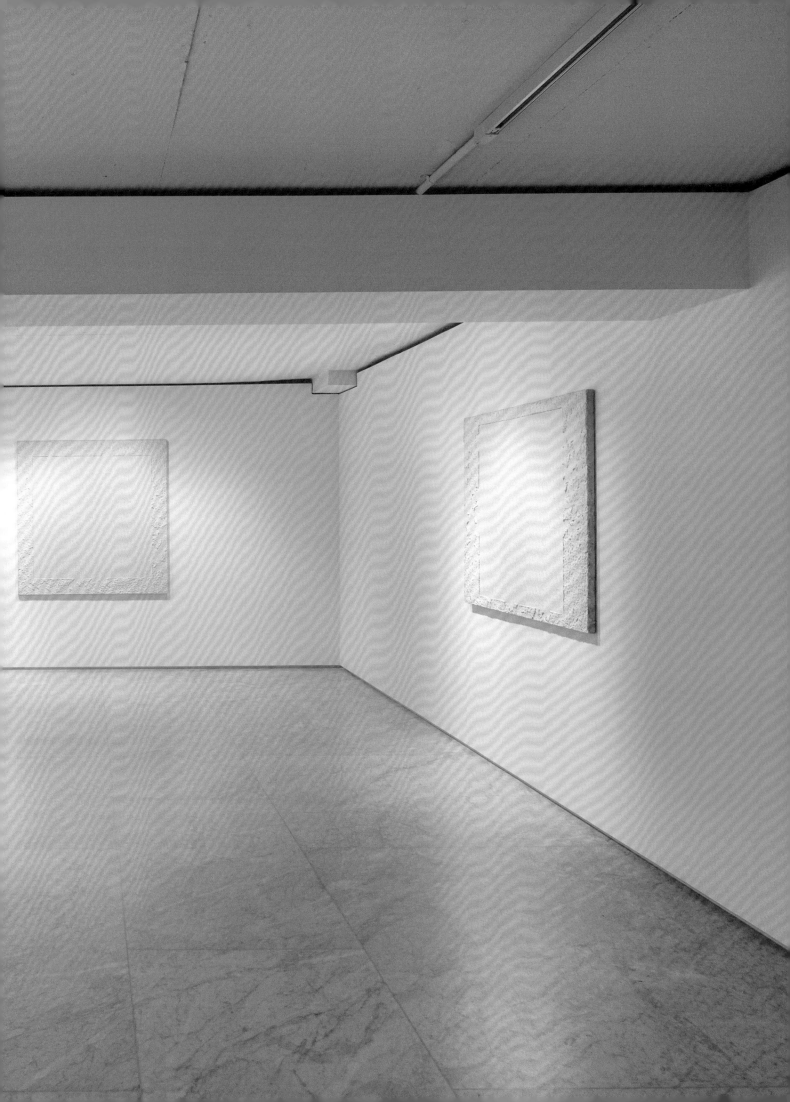

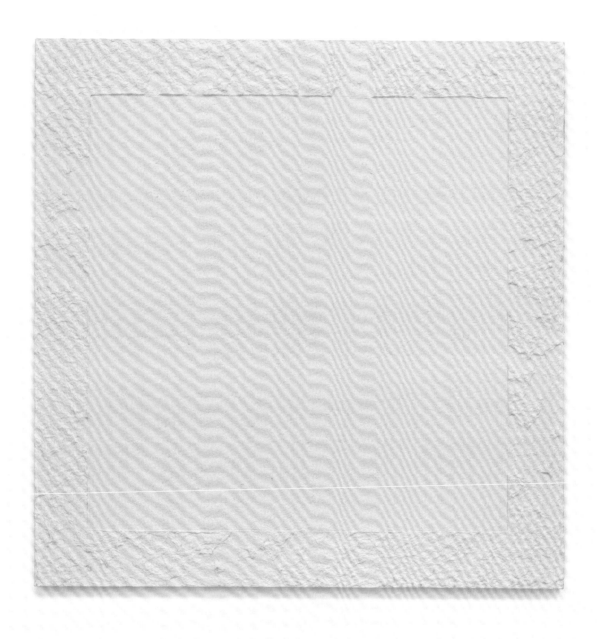

30. Meditation 231004, 2003, Tak fiber on cotton, 115 x 115 cm

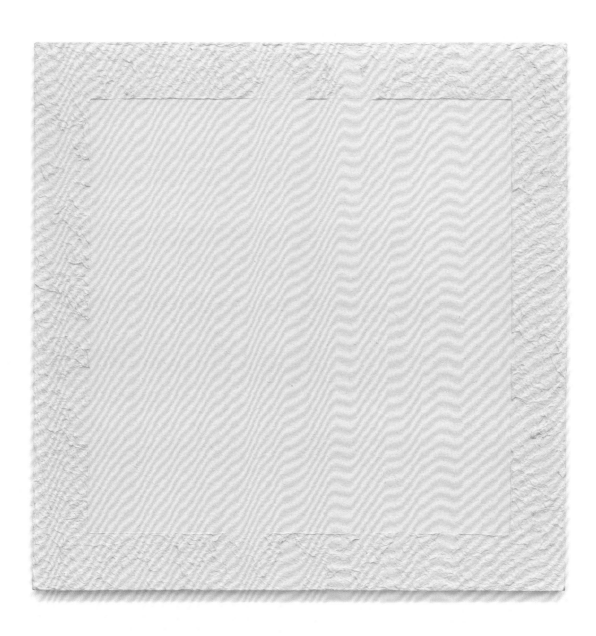

31. Meditation 231103, 2003, Tak fiber on cotton, 115 x 115 cm

32. Meditation 23704, 2003, Tak fiber on cotton, 91 x 116.7 cm

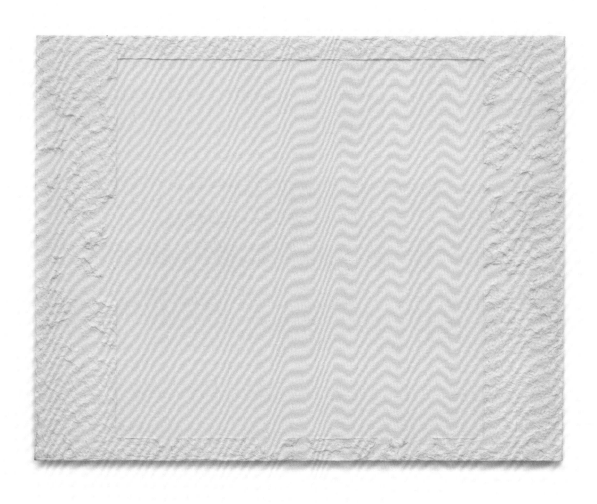

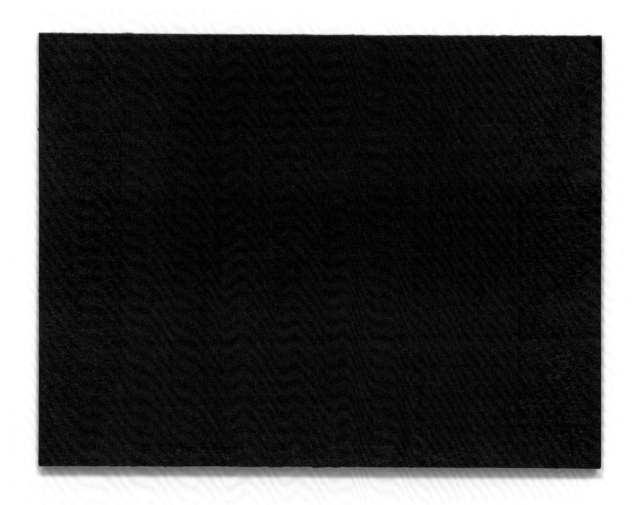

33. Meditation 97621, 1997, Tak fiber on cotton, 97 x 130.3 cm

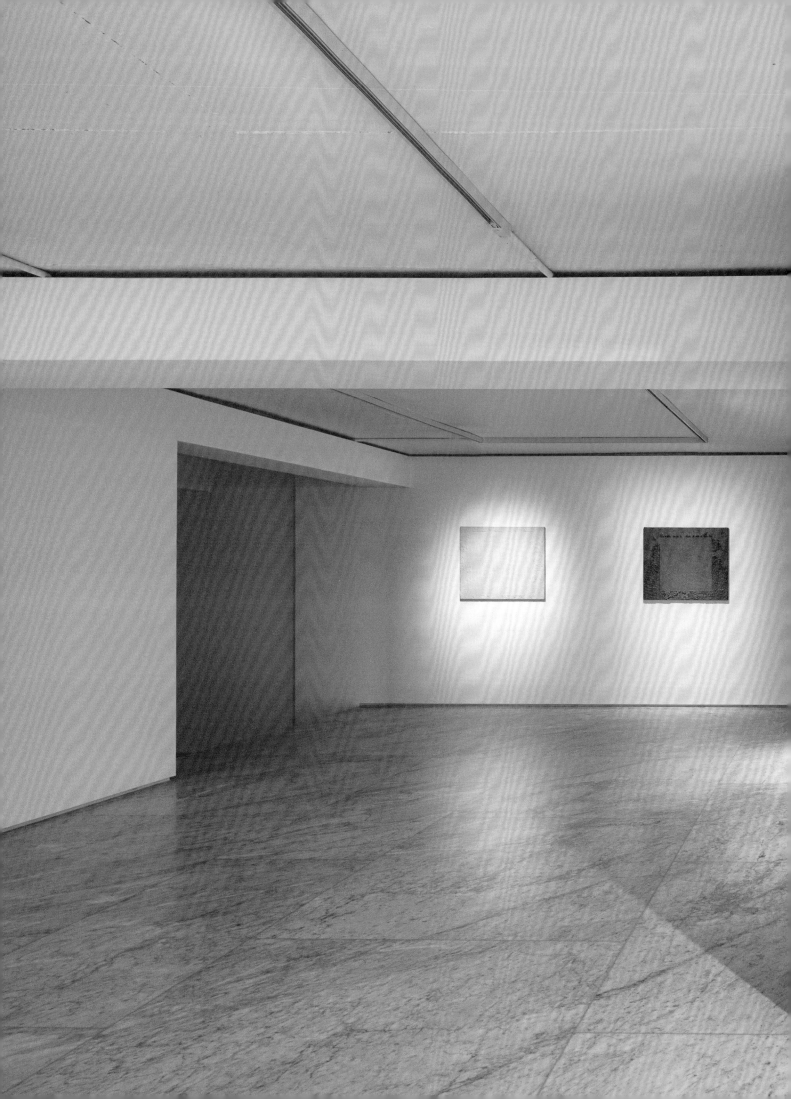

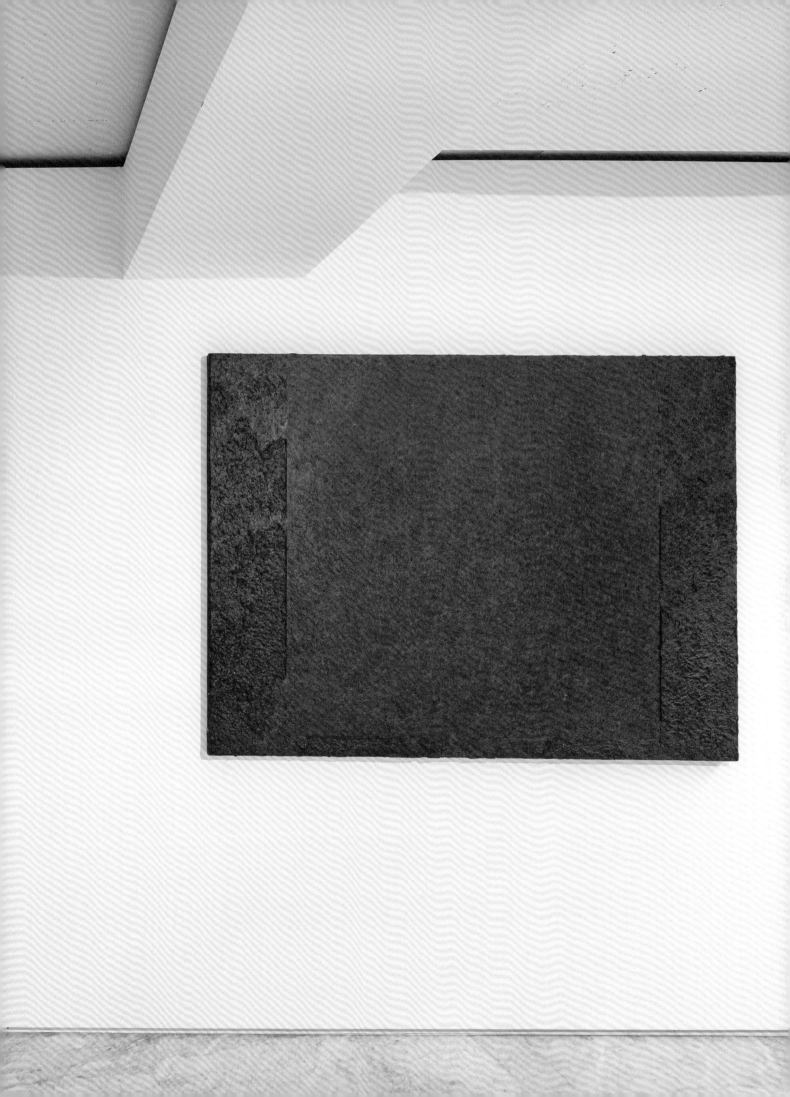

정창섭, 물(物)심(心)

Chung Chang-Sup

묵고(默考)

나는 우리의 민족적 감성의 상징인 닥(楮)을 통해서 나의 실존과 '닥'의 물성이 하나로 동화되기를 기대한다. 닥의 섬유질에 물기를 조절하고 '시간'의 추이를 주목하면서 마치 화강암의 표면처럼 혹은 질그릇의 느낌처럼 이루어지는 '평면'을 체험한다.

물질의 표면에 의도성 짙은 작위적 세계를 펼치려는 것이 아닌, '닥'이라는 물성의 의미에 나의 의식을 귀일(歸一)시키려는 자연주의적 순리의 조형관을 나는 시도하고 있다.

최근에 나는 닥에 색을 가해 보고 있다. 그러나 이 작업 역시 표면에 '바르는' 인위성을 배제하여 누르스름하게 혹은 청회색조로, 시간의 앙금 속에 바래고 번지는 은은한 차원을 지향하고 있다.

나의 체온과 체취가 녹아들어 신체화됨으로써 종이의 속성과 하나 되는 경지—그것이 내가 늘 바라보는 것으로, 그리려 하지 않으면서도 그려지며 만들려 하지 않고서도 만들어지는 것—그것이 나의 바람이다.

정창섭, 1990년대

작가 노트

'종속 이론'에 의하면 문화에서도 규모가 큰 세력권 속의 제(諸) 가치나 현상이 보다 미약한 세력 속의 이질적 가치나 현상을 흡수, 동화시켜 버림으로써 '통합'이 이루어지게 된다고 한다.

과연 미술 문화에서의 이런 현상은 어떻게 설명할 수 있을 것인가.

저 숱한 전통 논의는 바로 여기서부터 야기되는 갈등에서 비롯되는 것이리라.

이런 시점에서 나는 우선 전통에 대한 새로운 분석과 해석 그리고 이의 시대적 미감에 맞는 계승 문제를 주로 평면의 실재성에 의한 지적(知的) 사고와 행위의 흔적을 통하여 표출해 보려고 노력해왔다. 그러나 나는 전통 개념을 어떤 특정한 시공 속에 이미 선험적으로 완결된 가치 체계로 인식하려 들거나 민족적 이데올로기 밑에 세습적으로 묶어 두어야 할 고착된 유물이 아닌, 다분히 시대성에 충일하게 재구성해 낼 수 있는 하나의 원천적 기폭제와 '힘'으로 파악하려 하였다.

그리하여 화면에는 자율성을 부여하면서도 거의 무의식적으로 그리고 선입견이 배제된 상태에서 동양적 정신성과 전통적 이미지가 화면에 자연스럽게 스며들 수 있도록 하였다.

방법적으로는 주로 흐르고 번지며 자국을 남기는 설채(設彩)와 색의 침투 효과 및 백색 공간의 도입 등에 의해 보다 정신성을 존중하여 비색적(非色的) 요소가 강한 화면을 이루도록 하였으며 이 위에서 작가 자신의 의식이 영상적 아름다움에 의해 선명하게 만날 수 있도록 하였다.

즉 전통 의식과 정신 측면을 지향한다고 하여 고착된 사물과의 대화가 주가 되는 것이 아닌, 자아와 세계와의 유기적 소통에 의한 요해(了解), 재구성, 변전(變轉)의 패턴을 이루려 한 것이다.

또 하나 나는 우연적이고 일차적인 평면 위에 의도화되고 인지된 이차적 평면이 이합, 집산되는 의식과 무의식의 이원적 변주와 만남을 주시하려 하고 있다.

또한 이런 일련의 생각 속에서 나는 사색과 행위의 측면 못지않게 '시간성'에 주목하려 하고 있다.

즉 재래의 질량적 평면 위에서는 극명하게 만날 수 없었던 이 문제야말로 우연과 필연, 합리와 비합리, 정(靜)과 동(動), 의식과 무의식을 유기적으로 결구(結構)함으로써 행태적인 요소들을 정신적 차원으로 수렴, 환원시킬 수 있기 때문인 것이다.

따라서 나는 자연 작품에 현란한 색채 구사를 억제하려 노력하며 색채에 의한 시각과 이미지의 차단을 극복하기 위하여 이를 지성(知性)에 의해 제어, 조절하는 방식으로 나아가려 한다.

또한 탈(說) 서구적이면서 동시에 수묵에 의한 중국풍의 문인적(文人的) 사의(寫意) 취향이 지닐 수 있는 봉건성과 폐쇄성에 함몰되지 않고 어디까지나 현대 회화의 본령과 정신 속에서 무리 없이 한국적 전통 의식과 이미지가 세련된 조형 감각 위에서 표출될 수 있도록 고심하고 있다.

또한 나는 '드로잉' 작업을 통해서 필선 구사에 의해 명쾌한 정신성의 구현을 십분 추구할 수 있는 것으로 생각하여, 이 장르의 작업에도 차후 주력해 보려 하고 있다.

어쨌든 나는 자신의 조형 작업을 통해서 앞으로도 지속하여 한국인의 의식 속에 용해되어 있는 우리의 미감을 계발시키고 이를 확대 발전시켜서 결국 국제적 보편성과도 바람직하게 유기적으로 소통될 수 있도록 노력해 가리라.

정창섭, 1982년경

이 글은 1982년 5월, 『공간』 179호에 수록된 「시대적 미감에 맞는 전통의 계승작업」의 초안이다.

정창섭, (본)색과 (원)형의 인터페이스
: 정신적 매체의 시공을 구현하는 오브제-회화의 재창안

0.

정창섭(丁昌燮, 1927-2011)의 작업 세계를 21세기의 관점에서 새롭게 재대면, 재사고하는 길을 모색-제시하는 것이, 이 글의 목적이다.[1]

한국이 산업화에 박차를 가하던 1970년대 중반, 한일 우호 교류의 흐름 속에서, 한국식 모노크롬 회화의 실천과 담론이 형성됐다. 야나기 무네요시(柳宗悦)가 제시했던 민예론이 한국에서 한국인들의 버전으로 승화되는 시기였고, 따라서 소위 단색화와 그를 둘러싼 담론들은 산업시대인의 관점으로 새로운 민속/민족 전통을 발견하고 또 사고했다. 문제는, 오늘날 그것이 완결된 정태로서만 조명되고 또 이해되고 있기 때문에, 적잖은 사람들이 '단색화의 바탕에 앵포르멜의 고색추상이 존재한다는 사실'을 간과한다.[2] 초현실주의 운동의 원년 멤버들의 실체가, 제1차 세계대전 시기와 그 직후의 다다이스트였듯, 추상표현의자들의 실체는 미국 초현실주의였다. 로버트 라우센버그(Robert Rauschenberg)는 마르셀 뒤샹(Marcel Duchamp)으로부터 다다이스트적 아이디어를 계승함으로써 네오-다다의 시공을 창출했고, 그를 통해 추상표현주의의 시대를 가볍게 극복해버릴 수도 있었다.

마찬가지의 맥락에서, 나는 강조하고자 한다, 단색화가들의 외피 속에 숨겨진 진짜 알맹이는, 고색추상을 통해 '존재의 정당성'을 찾고자 몸부림치던 열혈 청년들이라는 사실을.

1. 맑은 바람 밝은 달

현대예술가 정창섭은, 충북 청주에서 태어났다. 한반도 문화권에서 충청도인의 기질은 관망하며 중도의 길을 추구하는 것으로 유명하다. 서두르지 않고 속내를 쉬이 드러내지 않지만, 중대한 역사적 순간이 오면 결정적인 영향력을 행사하곤 한다. 고집이 세고 의뭉스럽지만, 음흉하지는 않다는 것이 중평이다. 흥선대원군은 충청도인을 청풍명월(淸風明月)에 비유했다던가. 맑은 바람, 밝은 달의 선비 성품이라는 이야기였다. 한반도의 지리적 환경 속에서 보면, 중원에 해당하는 처지이니, 각 지방을 면한 입장에서 시대의 흐름을 읽고 순리를 따르는 지혜를 체득-전승하지 않을 수 없었을 터. 정창섭의 예술가 인생도, 그의 작업도, 딱 청풍명월과 같다.

2. 전후 추상미술 운동의 흐름 속에서

1927년생인 정창섭은 전후 추상미술가 세대에서 연장자에 속한다. 주요 단색화가들은 1928-1935년생 구간에 집중돼 있는데, 박정희 정권기의 한국 사회에서 산업화의 초석을 닦은 이들과 동년배다. "묻지 마라, 갑자생" 즉, 학도병/징용 1세대에 해당하는 한국의 1924년생부터는, 분야를 막론하고 크게 성취한 예술가를 찾기 어렵다. 생존 자체가 성공이었던 그들에겐, 해방공간의 시기에 성인으로서 가정을 꾸렸다가 한국전쟁의 혼돈 속에서 가족을 지켜야 했던, 더 큰 불운이 닥쳤더랬다. (그러한 불운은, 자녀와 손주 세대에게 대물림되는 경향을 띠었다.)

1946년 서울대학교에 예술학부 미술과에 입학한 정창섭은, 그러니까 운이 좋은 편에 속했다. 제1회 입학생으로서, 1951년 학부 과정을 마쳤고, 1953년 11월 제2회 ≪대한민국미술전람회(이하 '국전')≫에서 출품작 <낙조>(1953)로 특선하며 두각을 나타냈으니, '피란 수도 부산'에서 공부하는 과정이 쉽지야 않았겠지만, 그래도 '조국 재건'의 상승세 속에서 응분의 역할을 맡을 수 있었던 경우다. (국전 특선에 앞서, 1953년 8월 8일 고향 청주의 샛별 다방에서 '개인전람회'를 열었고, 1955년 제4회 국전에는 <공방>[1955, 당시 일부 신문 기사엔 <실내>로 잘못 소개되기도 했다]을 출품해 재차 특선했다.[3]) 대학 진학 이전, 즉 1941-1946년 시기엔 관립청주사범학교에서 공부하며 교육자로서의 기초를 닦았으니, 이후 교수-작가로서 미술계를 이끌기에 적임이기도 했다.

1948-1950년 시기 수화 김환기가 서울대학교 예술학부 교수로 일했으니, 정창섭은 추상미술 개척자 세대에게 직접 배운 몇 안 되는 서울대 출신 미술가이기도 했지만, 역시 1946-1959년 시기 미술대학을 설립하고 이끌었던 장발 초대 학장의 가톨릭계 애제자이기도 했다. (1954년 '가톨릭계 귀족'이었던 장발이 기획했던 ≪성(聖) 미술전람회≫에 초대된 적이 있기도 하고, 또 1968년엔 절두산 성당 벽화를 제작하기도 했다.)

1960년의 4·19 혁명으로 이승만 정권이 무너질 때, 청년 추상미술가들은 새로운 시대의 개막을 부르짖었지만, 장면-윤보선 정권은 사회와 경제 안정화에 실패하고 말았고, 1961년 5·16 쿠데타로 박정희 의장 체제가 출범할 때, 청년층과 국민 다수는 군인들의 정치 개입을 지지했다. 추상미술가들도 마찬가지였다. 1961년 군인 정권을 등에 업은 서세옥 등이 친일파와 축첩자(蓄妾者)를 축출하자는 정풍(整風) 운동을 전개함에 따라 7월 29일을 기점으로 장우성 등 서울대의 원로 교수들이 밀려나게 되고(장우성의 서류상 교수 사임 날짜는 10월 22일), 1961년 2학기 때부터 서세옥과 함께 정창섭은 신임 교수가 돼 포스트-장면 시대의 서울대 미대에서 학생들을 가르쳤다.[4] (장면 총리의 동생 장발은, 4·19 혁명 이후 1960년 9월부터 1961년 7월까지 이탈리아 주재 대한민국 대사 직무대행 서리로 일하느라 국외에 있었으므로, 서세옥의 이러한 쿠데타적 개혁을 저지할 수 없었다.)

1957년 조선일보 주최의 제1회 ≪한국현대작가초대전≫(덕수궁미술관)에 참가하며 앵포르멜 계열의 추상미술가로서 널리 인정을 받았던 정창섭은, 제10회와 제11회(전시가 열리지 않음)와 마지막 전시였던 제13회를 제외하고 매회 출품했는데, 미술평론가 이경성(당시 이화여자대학교 교수)이 ≪한국현대작가초대전≫의 초기에 주요 작가와 출품작을 지목해 평론할 때 정창섭은 빠지는 법이 없었다.[5] 그러나, 정창섭은, 본인 스스로 누차 강조했듯이, 소위 반국전파 미술가는 아니었다.

한국의 전후추상미술운동의 주역들은 홍익대학교 출신의 미술가들이었고, 그들은 1956년의 '반국전 선언' 이후, 현대미술가협회, 악튀엘, 한국아방가르드협회 등의 그룹 운동을 통해 변화와 성장을 도모했다. 그러나 정창섭은 특정 미술운동 그룹에 정식 회원이 된 적은 없었고, 전위적 흐름을 대변했던 ≪한국현대작가초대전≫에 참여하면서도, 국전에 비교적 꾸준히 출품했고, 또 1976년엔 국전 초대작가로서 심사위원을 겸하기도 했다.[6]

즉, 추상미술운동의 선두에 놓인 주요 작가 가운데 한 명이었음에도, 정창섭은 논란의 중심에 서서 파란을 일으키는 타입은 아니었으며, 언제나 순리에 조응하며 성찰적 작업을 전개하는, 그야말로 맑은 바람, 밝은 달과 같은 존재였다.

3. 추상 탐구로서의 그리기가, 그리지 않고 그리는 단계에 이르기까지

정창섭의 작업 세계가 자율성을 띠며, 작가를 통해 거의 스스로 성장해나간 과정을 살펴보면, 다음의 여섯 단계가 존재함을 알 수 있다: 1954-1956년의 반추상 탐구 시기, 1957-1965년의 앵포르멜 부류의 고색추상 실험기, 1965-1975년의 수묵추상적 매체 특정성 실험과 주제적 환원 시도의 시기, 1976-1980년의 한지 부착을 통한 매체 전환의 시기(<귀(歸)> 연작으로 대표되는), 1980년 이후의 짧은 발묵추상(수묵에서 채묵으로 전개됐던) 시기, 1983년 이후의 닥-지지체(tak-supports) 재창안 실험의 시기(<닥(楮)>과 <묵고(默考)> 연작으로 대표되는).

역시 정창섭의 예술 세계를 대변하는 것은, 펄프 상태의 닥으로 지지체를 재창안해 내는 1983년 이후의 연작들인데, 이 큰 흐름 속에서도 여러 가지 조응과 순응의 역사가 발견된다.

1983-1984년엔 <저(楮)> 연작을 통해 닥종이를 캔버스 위에 편 뒤 두드리거나 손으로 더듬어가며 '평원의 지형'을 탐구하고, 1985년엔 <닥> 연작을 통해 '기둥의 형상'을 탐구하고 주름을 통한 '면의 접합'을 재사고하는 단계에 이른다.[7] 이는 초기 입체파적 탐구의 과정에서 외곽선의 중첩을 사고하던 시절에 대한 회고로 뵈기도 했고, 또 '모보(모던보이)' 세대의 추상미술가 김병기의 분할하는 선들에 대한 비평적 화답으로 뵈기도 했다.[8]

한데, 1990년에 이르면 주름이 사라지고 무수한 손가락의 미동이 나타난다. 촉각성의 강조는 오히려 작업의 조각적 성격을 강화하는데, 이 지점에서 폴 세잔(Paul Cézanne)의 '양안 시각에 의존하는 그리기의 진실'에 부합하고자 하는 촉각적 붓질과, 오귀스트 로댕(Auguste Rodin)의 촉각적 표면에 대한 이야기를 해 볼 필요성이 나타난다.[9] 이 시기의 작업에서 추상-행위의 기억은 흔적으로 남고, 따라서 회상적 작업들이 폐허의 원점에 도달한 것처럼 뵈기도 했다.

(같은 시기인 1990-1991년 시기엔 분할선을 구사하는 정창섭식 색면추상도 시도되는데, 이는 1992-1994년 시기에 색을 입힌 캔버스 위로 백색의 닥을 앉히는 중층화 연작으로 연결된다.)

따라서, 1993년에 <묵고> 연작을 통해, 작가가 재해석된 순수평면에 저항하는 비평적 평면을 의제로 삼게 되는 것은, 폐허의 원점에서 이룬 조용한 재도약이나 다름없었다.[10] 이때부터 사각의 유닛을 연장하면서 1994년경 완전한 포스트-미니멀리즘의 재해석 단계에 도달하고, 추상미술의 역사와 자신의 실험에 대한 명상을 담아내며, '괴연(傀然)한 거장'으로서 말년성의 면모를 뵌다. 그러한 말년성을 통해, 작가는 1995-1996년경 지지체와 하나가 된 색채를 부활시키고, 1998년부터는 하드엣지에 대응하는 소프트엣지의 실험을 전개한다. (색채를 띠는 지지체로서의 화면 전개는, 1997년경 휴지기를 맞았다가, 2001-2003년경부터 다시 활성화된다.)

4. 형에서 색으로, 색에서 형으로, 그리고 추상 이상의 가치를 머금는 색형의 메타-인터페이스로

현대미술의 계보는 크게 둘로 갈린다. 색의 예술가와 형의 예술가의 역사로. 기존의 한계 상황에서 벗어나는 탈출구를 먼저 만드는 쪽은, 색채파인 경우가 많았다. 에두아르 마네(Édouard Manet)를 추종했던 초기 인상파가 그랬고, 추상표현주의의 흐름 속에서 묵묵히 후기-회화적 추상의 길을 개척했던 바넷 뉴먼(Barnett Newman)이 그랬다. 하지만, 후기인상주의 화가 가운데 한 명으로 간주됐던 세잔은 형의 문제를 다시 파고들었고, 특유의 회의하는 선묘와 색면의 중첩을 통해 '대상을 고찰하고 그려나가는 화가의 진실'을 그려내는 위대한 돌파구를 제시했다. 그렇기에 우리는 지금도 세잔을 현대미술의 아버지로 일컫는다. 세잔의 후예들은, 혹은 후예가 되기를 갈망하는 이들은 색의 문제에서 출발해 형의 문제로 회귀하는 여정을, 시대의 소명에 따라, 각자의 방식으로 수행했다. 앙리 마티스(Henri Matisse)가 그랬고, 파블로 피카소(Pablo Picasso)가 그랬다.[11]

한국의 전후 세대가 추상미술운동을 전개하는 과정에서, 이합집산하는 투쟁의 게임에 동참하지도 등을 돌리지도 않은 채, 고요하고 은은하게 자신의 길을 걸었던 정창섭은, 색의 미술가일까? 형의 미술가일까?

정창섭은 색채주의자로 뵈지만, 끝까지 형의 문제를 사고했던 아카데미즘의 예술가다. 고색추상, 즉 한국식 앵포르멜로 득의의 분수령을 일궜던 4·19 세대 청년 미술가들은, 1960년대 중반 이후 실험미술로의 매체적 확산을 시도하는 다원성의 과도기를 거쳐, 1973-1974년경 단색주의의 방법론(method)으로 변신을 시도한다. 1970년대 중반, 유신 독재의 심화 속에서, '이승만 정권 타도를 외쳤던 청년들'은, 내면에 침잠하는 보수적 아방가르드의 길을 선택했다.[12] 1970년대 중반, 정창섭도 함께 '자기-참조적 자율성(自己-參照的 自律性, self-referential autonomy)의 심화를 추구하는 방법론의 확립'이라는 시대의 과제에 화답했지만, 여타 단색화가들과는 묘하게 다른 성격을 띠고 있었다.[13]

1976년의 <귀> 연작에서부터 정창섭은, 인상파에서 세잔을 거쳐 입체파와 청기사파와 절대주의와 신조형주의로 이어지는 계보의 현대예술가들이 공히 극복의 대상으로 삼았던 순수평면을 재사고하기 시작했다. 앞선 시기(1968-1975년), 캔버스의 주름을 이용해 얼룩을 만들고 그를 통해 원형의 이미지를 창출하며 매체 특정성을 실험하는 동시에 주제 차원에서 환원을 시도했던 바, 환원의 중간 결론으로서 구현된 것이 <귀> 연작의 비어있으면서도 충만한 사각면들이었다. 이 메타-화면들의 구조를 나는, 환영주의를 야기해온 르네상스 이래의 순수평면에 저항해온 현대미술의 역사에 대한 화답으로 본다. 즉, 현대미술의 역사를 되돌아보며 숙고하는 메타-인터페이스였던 것.[14] (여기에서 멈췄다면, '원형 이미지의 구축과 파훼'를 거쳐, '물성에 충실하는 사각의 표면-지지체를 고안'해 낸 그는, 한국식 미니멀리즘의 작가로 남았을지도 모르겠다.)

1983-1984년의 <저> 연작에서 닥지를 통한 지지체의 재발명을 시도하고, 1985년엔 <닥> 연작을 통해 펄프 상태의 닥으로 지층에 가까운 구조들을 창출-탐구해낸다. 즉, 1985년에 비로소 지지체의 완전한 재창안에 성 공했던 것. 재창안과 동시에, 작가는 면의 분할과 조합을 재탐구하고자 애를 썼다. 그 과정에서 선배 세대인 김 병기의 분할하고 중첩하는 선들은, 정창섭의 세계에서 조합하는 면들의 다중-주름선들로 발현됐다.[15] 이 시기, 본격적으로 조각적 오브제가 된 정창섭의 지층 회화는, 예술가 자신과 작업 세계의 성장 과정을 되돌아보는 메타-인터페이스로 기능했다고 볼 수 있다.

한데, 1993년의 <묵고> 연작을 통해, 순수평면에 저항하는 비평적 평면을 품은 지층 회화를 창출하게 되면서, 1994년경 정창섭의 메타-인터페이스는, 형식주의의 의제를 되물으며 현대회화의 존립 조건을 재사고하는, 인 식론적 중층-관문이자 결절점으로 기능하기 시작한다.[16] 위대한 말년성의 메타-인터페이스는, 세잔과 로댕 이 래의 촉각적 시각성을 재사고하라고 요구하고, 그림을 마주하는 우리는, 그 요구를 포착하는 순간, 역사적 도 약을 위한 미묘한 움직임들을 보게 된다. 그것은 물리적 눈으로 보는 동세가 아니고, 감식안을 통해 뇌 속 시 뮬레이션의 세계가 기동될 때, 시각뇌·촉각뇌·청각뇌·후각뇌·미각뇌를 통해 유추해내는 메타-가시성의 총 체적 동세다.[17]

이러한 말년성의 메타-인터페이스를 통해 작가는, 지지체의 재료에 스며든 색채로써, 색면추상에서 야기됐던 초기 미니멀리즘 조각의 한계, 즉 표리부동의 모순을 극복하기도 했고, 한국에 사실상 부재했던 하드엣지에 시 대착오적으로 화답하는 소프트엣지의 실험을, 일종의 농담으로 제시하는 자신감을 드러내기도 했다.

1970년대 중반, 정창섭은 회화의 재창안을 통해 초기의 문제의식, 즉 고색추상이 다뤘던 '고대 한반도인의 정 신과 조형 언어의 원형 탐구'로 회귀했던 바, 여타 단색화가들과는 다른 길로 나아갔다고 볼 수 있다. 조선의 도 공이 빚던 백자와 분청의 미학 등을 기준점 삼아, 무념무상의 수행을 작업으로 제시하고자 했던 박서보, 윤형 근 등과 달리, 정창섭은 앵포르멜 운동 시기의 의제, 즉 고대적 설화의 상상계로 되돌아가려는 지향성을 통해 제 작업을 회귀와 숙고의 메타-인터페이스로 재창안하고 또 계발해냈다.

5. 2022년의 잠정적 소결

그렇기에, 정창섭의 메타-인터페이스 혹은 오브제-회화들은, 여전히 오늘의 미술가들에게 재탐구를 요구하는 '미완의 과제'이자 '미지 영역으로 나아가는 관문'으로 남아 있다.[18]

하면, 고색추상을 통해 찾고자 했던 '존재의 정당성'은 무엇이었을까? 그것은 일본 식민기의 《조선미술전람회》 를 통해 형성된 관학파 미술과 그를 계승한 국전의 미술이 갖는 '정당성의 결여'를 극복해야 한다는 의식이었 고, 이승만과 해방 귀족들의 권세를 무너뜨려야만 한다는 4·19 청년 세대의 분노이기도 했으며, 월북 미술가 들의 민족적 사회주의 리얼리즘에 대항하는 '정당한 모더니즘'을 확보해야만 한다는, '절박한 열세 의식의 표 현형'이기도 했다. 그렇기에 한국의 경제력이 북조선을 능가하는 1970년대 초반에 이르러서야 비로소, 모종의 집단적 자신감을 바탕으로 '실존의 방식'을 개인화한 방법론으로서 제시할 수 있게 됐던 것이다.[19] 한데, 정창 섭만은, 1970년대 중반 이후, 미결 과제로 남은 '존재의 정당성' 이슈로 회귀했다. 결과적으로, 정창섭의 재창 안된 추상 회화-오브제는, 한국의 현대미술가와 현대미술의 실존적 당위성을 성찰하는 인식론적 포털(portal) 로 기능한다.

1960년대에 미니멀리즘 담론을 이끌었던 미술사학자 바바라 로즈(Barbara Rose, 1936-2020)는, 1996년경 "정체성을 따르는 추상(Abstraction as Identity)"이라는 새로운 요해 방식을 제시했더랬다. 추상미술가가 다 양한 정체성 유산을 활용할 때, 시의적절하고 독창적인 복합성(의 시공)을 창출할 수 있다고 봤던 것. 나는 그의 해석틀을 "정체성을 갱신하고 재창출하는 추상"으로 재정의해, 한국의 전후 현대미술 혹은 단색화 등에 적용해 보고 싶다. 동시에, '공예적 프로세스를 통한 그리기의 초극'이라는 차원에서 탈식민 지역의 추상미술과 그 역 사를 재조명해 볼 수도 있겠다.

정창섭의 추상미술은, 한국의 전후 청년 세대들이 감당해야 했던 실존적 정당성의 취약성으로부터 태어났다. (입체파적 경향을 뵀던 초기작 <공방>에서도, 정창섭은 현대화가로서 나는 누구이고, 장차 뭘 해야 하는지 묻고 답하고 있다.[20]) 역사적 정당성을 구축해나가던 1970년대의 한국 사회에서, 그도 자신감을 갖고 한국의 문화적 원형으로부터 재도약을 추구하며 여타 단색화가들과 유사한 길을 걸었지만, 묘하게도 그의 메타-인터페이스 혹은 오브제-회화들은, 초기의 문제로 돌아갔다.

그런데 작업의 자율성은, 언제고 '저자의 의도' 이상의 가치를 포괄해 내기 마련. 나는 정창섭의 메타-인터페이스 혹은 오브제-회화들이, 닥이라는 아시아 혹은 세계 공통의 물질을 통해, 그가 그토록 갈망했던 '현대적 한국성'이라는 범주를 이미 오래전부터 뛰어넘기 시작했다고 생각한다. 근미래의 시점에서 정창섭의 예술을 바라보면, '한국성(혹은 한국적 현대성)의 해체와 재구성'이라는 가능성을 배태한 철학적 질문들이 된다. 나는 당신도 그 질문들을 마주하고 답을 찾는 여정에 함께 하길 희망한다.

1) 한일 합작 시대 특유의 이어령식 문화 특질론에 바탕을 둔, '(창호지) 문의 은유', '(한지를 바른) 문의 제유'를 통한 기존의 해석을 극복해 보고자 한다.

2) '고색추상(古色抽象)'이란, 한국식 앵포르멜 운동의 다른 이름이다. 광복과 한국전쟁 이후 소위 '친일 성향의 해방 귀족'들이 지배하는 상황을 초극하길 갈망했던 한국의 전후 청년세대 추상미술가들이, 한반도의 설화적 고대(많은 경우 고대의 기준점은 통일신라였다)로부터 영감을 얻고 그를 바탕으로 추상의 언어 혹은 시공을 창출하고자 했던 성격을 강조한다. 이는, 탈식민 상황에서의 민족주의적 모더니즘이, 실존적 정당성을 찾아나가는 과정의 산물이기도 했다. (비고: '해방 귀족'이란 멸칭은, 일본 식민기 하위 주체로서 엘리트의 자리를 점했던 조선인들이 광복 이후 일본인 지배 계급의 자리에 올라 특권층으로 군림했기에 탄생했다.)

하지만, 유럽의 추상미술운동도 특정 단계에서 '고대의 재해석을 통해 원점으로 회귀하고 새로운 출발을 도모하려는 경향'을 드러냈던 바 있었으니, 한국에서만 발견되는 패턴은 아니다. 예컨대, 마티스는 <삶의 기쁨(Le bonheur de vivre)>(1905-1906)을 통해 고대적 상상력을 바탕으로 아르카디아(이상향)를 구현-제시했댔고, 카지미르 말레비치(Kazimir Malevich)는 선언문「입체주의에서 절대주의로: 회화에서의 새로운 리얼리즘(From Cubism to Suprematism: The New Realism in Painting)」(1915/1916)에서 "중요한 것은 단지 감수성밖에 없다. 바로 이 길을 통해 예술, 즉 절대주의는 재현을 벗어난 순수표현에 이르게 된다. 예술은 감각 외에 아무것도 감지할 수 없는 '사막'에 도달했다. [...] 절대주의의 사각형 및 그 이념에서 생겨난 형태들은 원시인의 기호에 비견할 수 있다"라고 주장하며, 보다 분명한 환원의 논리와 그를 통한 새 출발의 의지를 공표했던 바 있었다.

전후 한국의 고색추상 경향은, 1965년 한일 외교 정상화가 이뤄지고, 1960년대 중후반 문화예술교류가 활발해지면, 점차 힘을 잃고 다종다양한 실험미술의 흐름에 자리를 내어주게 된다. 흥미롭게도, 고색추상의 주요 미술가들은, 1973-1974년을 기점으로 단색화의 메소드를 창안하게 되고, 1975년 이후 본격적으로 단색주의의 길을 걷게 된다.

3) 1954년 제3회 국전에 무감사 출품했던 <옹기 시장>(1954)은, 김환기의 신랄했던 경향신문 평문(1954년 11월 7일 자 4면)을 통해, "옹기의 형태가 화면에 애매하게 포입되어 있다. 추상과 사실의 형태의 융합에 있어 깊은 연구가 있기를 바란다"라는 촌평을 받기도 했다.

국립현대미술관에 소장된 1956년작 <백자>는, 그러한 스승의 비평을 염두에 놓고 작업한 결과 가운데 하나로 뵌다.

4) 4·19 혁명과 5·16 쿠데타 이후, 정풍 운동을 통해 '해방 귀족'을 몰아내고자 하는 흐름이 전개될 때, 가장 손쉬운 방법 가운데 하나가, '축첩자'로 낙인을 찍는 일이었다. 이승만 정권기만 해도, 일제하 총동원 시기에 징용 등을 피하고자 조혼했던 이들 가운데 성인기에 신여성을 만나 중혼 상태에 놓인 경우가 적잖았다. (김환기처럼 정식으로 이혼하고 분재한 뒤, 재혼한 경우는 드물었다.) 광복 이후 사회 각계에서 활약하던 기혼 신여성 다수는, 4·19 혁명과 5·16 쿠데타 과정에서 '친일파의 첩', '부정부패의 주범'이라는 비난을 받았고 이후 공적 영역에서 설 자리를 잃고 만다.

5) 1957년의 제1회 《한국현대작가초대전》에 출품했던 <회색의 광장>(1957)은 평론가 이경성으로부터 "시각적인 설화가 내재하고 있다"는 평을 받았고, 1958년의 제2회엔 <고화(古話)>(1958) 등을 출품했으니, 고색추상의 경향을 이어갔던 것으로 뵌다. 완전한 추상으로 전환한 것은 1958-1961년의 <심문(心紋)> 연작을 통해서였고, 이후 <백의 집결>(1961), <작품 63>(1963), <작품 64>(1964)에 이르기까지 두터운 마티에르를 실험하며, 고대적 한국미의 원형을 '추상으로의 환원'으로서 탐구하는 경향을 추구했다.

6) 1955년 장발이 이끄는 서울대파가 설립한 한국미술가협회에 이름을 올린 적이 있었지만, 1961년 김병기, 서세옥 등과 함께 탈퇴했다.

7) 작가는 1986년경 혹은 그 이후까지 <닥> 연작을 <저> 시리즈라고 불렀고, 나중엔 제목을 혼용하는 시기가 있었다. 유업 관리자 측에서 전작집 발간 준비를 통해 일목요연하게 정리할 필요가 있다. 일단 본 논고에서는, 편의상 초기의 <닥> 연작을, 즉 1983-1984년 시기의 작업을 <저> 연작으로 별칭했다.

8) 추상미술가 김병기는 1954년부터 1957년까지 서울대 미대에서 "현대미술 형성론"을 강의하고 4학년생 실기 지도도 맡았다.

9) 로댕의 비서였던 시인 라이너 마리아 릴케(Rainer Maria Rilke)는, '대상의 표면을 통해 파악된 내적인 것'을 이야기하며, 요동치는 시각적/촉각적 표면을 통해 단순한 자연의 재현 이상의 가치, 즉 동세가 창출된다고 평론했다.

10) 16세기 이래 유럽에서 현대적 원근법이 형성-발전하는 과정에서, 미술가들은 회화의 접면을 순수평면(pure surface [reinen Fläche])으로 인식하기 시작했고, 그와 함께 조소/조각의 접면을 순

수매스(pure mass [reinen Masse])로 인식하기 시작했다. 하지만, 현대적 원근법의 의의를 비평적 시점에서 재인식하게 된 것은, 기껏해야 1890년대 이후의 일이었다. 현대적 원근법을 메타-비평하려는 태도를 드러낸 것은, 세잔과 같은 화가들이 처음이었고, 대략 두 세대 이후에야 그에 상응하는 의식을 지닌 미술사학자들이 등장했다.

하인리히 뵐플린(Heinrich Wölfflin)이 1915년 출간한 저작 『미술사의 기초 개념: 근세 미술에 있어서의 양식 발전의 문제(Principles of Art History: The Problem of the Development of Style in Early Modern Art [Kunstgeschichtliche Grundbegriffe: Das Problem der Stilentwicklung in der neueren Kunst])』에서 16세기 미술과 17세기 미술 사이에 존재하는 질적 전환의 성격을 규명한 것, 에르빈 파노프스키(Erwin Panofsky)가 1927년에 출간한 저작 『상징 형식으로서의 원근법(Perspective as Symbolic Form [Die Perspektive als "symbolische Form"])』에서 현대적 원근법의 역사적 의의와 작동 방식을 규명해냈던 것, 알프레드 바 주니어(Alfred Barr Jr.)가 1929년 뉴욕 현대미술관의 첫 전시로 기획한 《세잔, 고갱, 쇠라, 반 고흐(Cézanne, Gauguin, Seurat, van Gogh)》에서 화이트큐브의 전시 문법을 제시해 유럽 현대미술의 역사를 재고찰해냈던 것, 이 세 가지 모두, 16세기 이래의 현대적 원근법이 형성된 과정과 그 의의를 비평적 시점을 통해 재인식하는 과정에서, 순수평면을 메타-고찰의 공간으로 상정하게 된 귀결에 다름 아니었다. 이와 같은 인식론적 전환은 거의 즉각적으로 모더니즘을 추동해냈고, 곳곳에서 현대미술의 크고 작은 성취가 이어졌다.

11) 추상미술의 아버지로 간주되는 바실리 칸딘스키(Wassily Kandinsky)의 인생도, 색의 문제로 시작해 형의 문제로 귀착하는 과정에 가까웠다. 말년의 뉴먼에게 영향을 받았던, 칼 안드레(Carl Andre), 리처드 세라(Richard Serra) 등 미니멀리스트 조각가들도, '색의 문제에서 출발한 이들'을 밀어내고 형의 문제로 역사의 변곡점에서 헤게모니를 장악했다.

한국이나 중국, 일본의 경우엔 어떨까? 김환기는, 넓은 의미에서의 초현실주의에서 출발해, 바우하우스식 구성주의와 칸딘스키의 종합주의를 토착화하는 시기를 거쳐, 결국엔 색점의 세계로 환원하는 길을 찾았으니, 형의 문제에서 색의 문제로 나아간 모습이다. 유영국도 크게 보면, 형의 추상에서 색의 추상으로 나아간 예술가다. 리커란(李可染)의 경우는, 인상파의 문제의식으로 빛의 문제를 다루다가 색으로 혁신을 잠시 이뤘지만, 역시 입체파적 문제의식으로 수묵화에 없던 형의 논리를 다중 시점의 화면으로 종합-제시해낸 형의 화가다. 반면, 장대천(張大千)은 형이라기보다는 색의 작가로 출발해 붕해하는 화면의 색채로 성취를 거둔 대가다. 시라가 가즈오(白髪一雄)는 형의 예술에서 출발해 추상표현주의에 대항하는 색채의 장을 일궈냈으니, 역시 색채파에 속한다. 이우환의 경우는 형의 작가, 더 명확히 말하면 형의 환원을 이리저리 탐구해온 작가다. <선으로부터>와 <점으로부터>(두 연작 모두 1973년 9월 동경화랑에서 열린 개인전에서 최초 공개)를 시작할 때, 색의 선택에 관해선 단순하게 사고했다고 증언한 바 있기도 하고.

12) 이승만 정권이 무너지던 1960년, 앵포르멜 운동의 주역들은 대부분 20대 후반-30대 초반의 청년이었다. 하지만 1970년대 중반에 이르면, 그들은 이미 40대 중후반에 이른 상태였고, 단색화의 방법론—'보수적 아방가르드'라는 모순성을 특징으로 하는—에 매진하며, 산업화 시대의 사회 문제를 외면하는 모순 상태에 빠지게 된다.

13) 확산과 환원의 주기 운동을 반복해온 현대미술의 역사 속에서, 색과 형의 문제는 꼬리에 꼬리를 물며 의제 전환의 국면들을 형성해왔으니, 오늘의 상황에 비춰봐도 여전히 흥미로운 잣대가 된다. 가장 잘 알려진 역사적 국면 전환의 사례는, 추상표현주의에서 미니멀리즘에 이르는 계보다. 무의식적 글쓰기라는 초현실주의의 방법에서 파생된 추상表현주의가, 회화의 평면을 시각장과 중첩해 사고하는 경향을 낳았고, 그에 뒤이어, 후기 회화적 추상의 의제가 파생될 때 색면추상의 이슈가 과도기를 형성했다. 그때 색면추상회화를 조각으로 전환해 보려는 이들이 돌출했고, 원색의 의제가 형태의 의제와 결합하면서 색과 형의 최적화를 추구하는 "기초적 형태들"의 미니멀리즘 조각이 탄생했다. 그러나, 물질의 본성에 충실한 형태와 색채의 구현을 추구하는 참된 미니멀리스트들이 나타나면서, 색의 의제는 설 자리를 잃고 말았다. 하면, 한국의 전후추상미술의 전개 속에서 색과 형의 문제는 어떠한 방식으로 전환의 계기들을 창출해왔을까?

14) 정창섭의 메타-인터페이스를, 라우센버그의 <지워진 드 쿠닝(Erased de Kooning Drawing)>(1953)이나 조 베어(Jo Baer)의 <무제(Untitled)>(1964-1972)에 대한 화답으로 독해해 봐도 퍽 재미있다.

15) 전후 청년 세대 추상미술가 가운데 서울대 출신들, 즉 권영우, 정창섭, 정상화, 윤명로의 공통점은, 선의 중첩을 통한 조형 언어의 구축에 매진했다는 점이다. 세잔 이래의 '회의하고 주저하는 선의 구사'를 통해 추상조형의 논리를 탐구하는 면모는, 윤형근, 박서보, 하종현 등 소위 홍대파의 거침없는 선의 구사와 흥미로운 대조를 이룬다. (반면, 서울대파 가운데 아래 세대에 속하는 이강소, 김호득은 이미지로 독해될 수 있는 일필휘지의 선을 최적화된 추상행위의 과정을 통해 구사하는 특질을 뒀다.)

16) 1993년 교수직에서 정년 퇴임하면서, 이러한 전환을 이루게 됐다.

17) 화가의 눈과 손으로 표면을 더듬듯이 작업을 훑어보는 순간, 혹은 평론가 지바 시게오(千葉成夫)처럼 눈을 감고 정창섭의 작업을 보는 순간, 소리와 냄새와 맛이 함께 느껴질 것이다.

18) 스티브 잡스(Steve Jobs)는, 컴퓨팅 인터페이스의 제안을 통해 멀티미디어의 시공을 창출하는 과정에서 크게 기여한, 앨런 케이(Alan Kay)의 말을 즐겨 인용하곤 했다: "소프트웨어에 진심인 사람은 하드웨어의 발명에 나서게 된다(People who are serious about software should make their own hardware)." 한국의 전후 추상미술의 방법론적 전환에도 적용되는 이야기다.

19) 한국의 모더니즘 미술은, '현대적 시공이 존재할 수 있도록 정당성을 창출하는 프로젝트'로서 전개됐다. 그렇기에 추상미술가들은, 민족기록화 사업 등에도 거리낌 없이 참여할 수 있었다. (1977년 8월 한계에 도달한 민족기록화 사업이 변화를 모색할 때, 정창섭 등 참여작가 5인의 동남아 연구 여행이 추진됐다: 김태, 정창섭, 최대섭, 문학진, 이종상 참여. 20여 명의 작가를 선정해 민족기록화를 양산하던 체제에서 벗어나, 5인에게 심도 깊은 작업을 주문했다.)

20) 입체주의 이후의 황금분할 살롱의 화가들은 중첩하며 어긋나며 분할하는 선들을 통해, 세잔의 외곽선에 화답했던 조르주 브라크(Georges Braque)와 피카소의 문제의식을 계승-극복하고자 했다. 후학의 입장에선, 기하학적 단순화가 문제가 아니고, 대상을 고찰하는 분석적 현대주의자의 시선과 그 과정을 화면 위에서 종합해나가는 방식의 체득이 핵심이 된다.

이정우 (임근준), 미술·디자인 역사/이론 연구자

Chung Chang-Sup

Education

1951 Bachelor's Degree in Painting, College of Fine Arts, Seoul National University, Seoul, Korea

Selected Solo Exhibitions

2022 PKM Gallery, Seoul, Korea

2021 Axel Vervoordt Gallery, Hong Kong

2020 Axel Vervoordt Gallery, Antwerp, Belgium

2016 Kukje Gallery, Seoul, Korea

 Galerie Perrotin, Hong Kong

2015 Galerie Perrotin, New York, USA

 Galerie Perrotin, Paris, France

 Johyun Gallery, Busan, Korea

2010 National Museum of Modern and Contemporary Art, Gwacheon, Korea

2007 Pyo Gallery, Seoul, Korea; Beijing, China

2003 Gallery Euro, Seoul, Korea

1999 Tokyo Gallery, Tokyo, Japan

 Park Ryu Sook Gallery, Seoul, Korea

 Sigong Gallery, Daegu, Korea

1996 Gallery Hyundai, Seoul, Korea

1995 Mark Moore Gallery, Los Angeles, USA

1994 Tokyo Gallery, Tokyo, Japan

 Space World, Busan, Korea

1993 Ho-Am Art Gallery, Seoul, Korea

1985 Ueda Gallery, Tokyo, Japan

 Cheongtap Gallery, Cheongju, Korea

1984 Art Core Center, Los Angeles, USA

 Duson Gallery, Seoul, Korea

Selected Group Exhibitions

2021 *Resonance*, Horim Museum Sinsa, Seoul, Korea

 Spirit and Composure, Museum SAN, Wonju, Korea

 Lunar Sonata: Hanji Works and Contemporary Art, Jeonbuk Museum of Art, Wanju, Korea

2020 *Psychic Wounds: On Art & Trauma*, The Warehouse, Dallas, USA

2019 *Johyun 30 years*, Johyun Gallery, Busan, Korea

2018 *Return*, Axel Vervoordt Gallery, Antwerp, Belgium

2017 *Unpacked: Contemporary Works from Private Collections of Northern California*, Museum of Sonoma County, Santa Rosa, USA

 Arts of Korea, Brooklyn Museum, New York, USA

 The Ascetic Path: Korean DANSAEKHWA, Erarta Museum of Contemporary Art, St. Peterburg, Russia

 Rhythm in Monochrome: Korean Abstract Painting, Tokyo Opera City Art Gallery, Tokyo, Japan

 Intuition, Palazzo Fortuny, Venice, Italy

2016	*Inaugural Exhibition: The Myth of YÔBAEK, Vacating a Pictural Surface*, Cheongju Museum of Art, Cheongju, Korea
	When Process Becomes Form: Dansaekhwa and Korean Abstraction, Boghossian Foundation Villa Empain, Brussels, Belgium
	Dansaekhwa, l'aventure du monochrome en Corée, des années 70 à nas jours, Domaine de Kerguéhennec, Bignan, France
2015	*Dansaekhwa*, Palazzo Contarini Polignac, Venice, Italy
	The past, the present, the possible, Sharjah Biennial 12, Sharjah, UAE
2014	*The Art of Dansaekhwa*, Kukje Gallery, Seoul, Korea
2012	*Dansaekhwa: Korean Monochrome Painting*, National Museum of Modern and Contemporary Art, Gwacheon, Korea; Jeonbuk Museum of Art, Wanju, Korea
2011	*Korean Abstract Painting_10 Perspectives*, Seoul Museum of Art, Seoul, Korea
	Tell Me Tell Me: Australian and Korean Art 1976-2011, National Museum of Modern and Contemporary Art, Gwacheon, Korea; Museum of Contemporary Art, Sydney, Australia
	Inaugural Exhibition: Qi is Full, Daegu Art Museum, Daegu, Korea
2010	*2010 in the Midst of the Korean Contemporary Art*, Gallery Hyundai, Seoul, Korea
2009	*The Color of Nature: Monochrome Art in Korea*, Wellside Gallery, Shanghai, China
2008	*Korean Abstract Art: 1958-2008*, Seoul Museum of Art, Seoul, Korea
	Drawing from Korea: 1870-1970, Seoul Olympic Museum of Art, Seoul, Korea
2007	*Abstract Art: amusement on the borders*, Nam-Seoul Museum of Art, Seoul, Korea
2006	*Masters and Leading Artists of Korean*, Leehwaik Gallery, Seoul, Korea
2004	*Monochrome Painting of Korea, Past and Present*, Seoul Museum of Art, Seoul, Korea
	Permeating, Leehyun Gallery, Daegu, Korea
2003	*White Spectrum-Joseon White Porcelain and Korean Contemporary Art*, Joseon Royal Kiln Museum, Gwangju, Korea
	Understanding of Abstract Paintings, Sungkok Art Museum, Seoul, Korea
2002	*Korean Contemporary Art from the Mid-1970s to Mid-1980s: Age of Philosophy and Aesthetics*, National Museum of Modern and Contemporary Art, Gwacheon, Korea
	Aesthetic of Plane in the 70s Hidden by Monotone, Hanwon Museum of Art, Seoul, Korea
	100 Masterpieces of Modern Korean Painting, National Museum of Modern and Contemporary Art, Deoksugung, Seoul, Korea
	4 Korean Contemporary Artists: Chang-Sup Chung, Se-Ok Suh, Tschang-Yeul Kim, Seo-Bo Park, Gallery Bijutsu Sekai, Tokyo, Japan
2001	*A Shadow of Myo-Oh*, Sagan Gallery, Seoul, Korea
2000	*An Aspect of Contemporary Art*, National Museum of Modern and Contemporary Art, Gwacheon, Korea
	What is so of itself, POSCO Art Museum, Seoul, Korea
	The 3rd Gwangju Biennale Special Exhibition: The Facet of Korean and Japanese Contemporary Art, Gwangju Museum of Art, Gwangju, Korea
	Plane as Spirits, Busan Museum of Art, Busan, Korea
1999	*Korean Art of 50 Years (Part 2)*, Gallery Hyundai, Seoul, Korea
	Corée Pays du Matin calme, Musée des Arts Asiatiques, Nice, France
1999-78	*Ecole de Seoul*, Kwanhoon Museum; National Museum of Modern and Contemporary Art, Seoul, Korea
1998	*Les Peintres du Silence*, Musée de Montbeliard, Montbeliard, France
1996	*Invitational Exhibition for the 50th Anniversary of Seoul National University: Seoul National University and Korean Art*, Seoul National University Museum, Seoul, Korea

	Korean Monochrome Painting in the 1970s, Gallery Hyundai, Seoul, Korea
	The Spirit of Korean Abstract Painting, Ho-Am Art Gallery, Seoul, Korea
1995	*The Nature of Korea: Meditation-Expression*, Park Ryu Sook Gallery, Seoul, Korea
	Art Contemporain Coréen, Couvent des Cordeliers, Paris, France
	The Korean Modern Painting for Fifty Years, Hanlim Gallery, Daejeon, Korea
	Inaugural Exhibition of POSCO Center, POSCO Art Museum, Seoul, Korea
1994	*Korean Art: Light and Color*, Ho-Am Art Gallery, Seoul, Korea
1993	*12 Contemporary Artists from Korea*, Miyagi Museum of Art, Sendai, Japan
	Korean Art, Yesterday and Today, Hanlim Gallery, Daejeon, Korea
	14 Korean Contemporary Artists, Sigong Gallery, Daegu, Korea
1992	*Working with Nature: Traditional Thought in Contemporary Art from Korea*, Tate Liverpool, Liverpool, UK
	Korean Contemporary Art, Shimonoseki City Art Museum, Shimonoseki; Niigata City Art Museum, Niigata; Kasama Nichido Museum of Art Foundation, Kasama; Mie Prefectural Art Museum, Tsu, Japan
	Line and Expression, Ho-Am Art Gallery, Seoul, Korea
1991	*Today's 9 Artists*, Jean Gallery, Seoul, Korea
	A Grouping for the Identity of Korean Contemporary Art III: A Period of Conflict and Confrontation, Hanwon Gallery, Seoul, Korea
	5 Contemporary Artists, Hankuk Gallery, Seoul, Korea
	Inaugural Exhibition: Korean Contemporary Art, Sonje Museum of Contemporary Art, Gyeongju, Korea
	The 21st Anniversary Exhibition: Contemporary Art Exhibition by 25 Artists, Gallery Hyundai, Seoul, Korea
	A Grouping for the Identity of Korean Contemporary Art I: Dawn of Korean Contemporary Art, Hanwon Gallery, Seoul, Korea
1990	*Korean Contemporary Art*, Total Art Museum, Seoul, Korea
	Inaugural Exhibition: Korean Art-The Current Status, Hangaram Art Museum, Seoul Arts Center, Seoul, Korea
1990-83	*Contemporary Art Festival*, National Museum of Modern and Contemporary Art, Deoksugung, Seoul; Gwacheon, Korea
1989	*Contemporary Art for the Benefit of the Safeguard of Venice and The Great Wall of China*, sponsored by UNESCO, Palace Museum, Beijing, China
	Hiroshima, Hiroshima City Museum of Contemporary Art, Hiroshima, Japan
	89 Artists, Kwanhoon Museum, Seoul, Korea
1988	*Contemporary Korean Paintings*, National Museum of History, Taipei, Taiwan
	Inaugural Exhibition: Modernism in Korean Art: 1970-1979, Hyundai Department Store Gallery, Seoul, Korea
	Olympiad of Art, National Museum of Modern and Contemporary Art, Gwacheon, Korea
	Inaugural Exhibition: Invitational Exhibition of Contemporary Artist, Chosun Ilbo Art Museum, Seoul, Korea
	4 Korean Painters, Tokyo Gallery, Tokyo, Japan
1987	*4 Contemporary Korean Artists*, Laboratory Gallery, Sapporo, Japan
	39 Contemporary Artists, Commemorate for the Professor Kim Swoo Geun, SPACE Gallery, Seoul, Korea
	Chung Chang-Sup and Park Seo-Bo, SPACE Gallery, Seoul, Korea

1987-75 *Seoul Contemporary Art Festival*, Korean Culture and Arts Foundation Center, Seoul, Korea

1986 *Commemorative Exhibition of the Opening of the New Museum: '86 Seoul Contemporary Asian Art Show*, National Museum of Modern and Contemporary Art, Gwacheon, Korea

Paper+Pencil=Drawings by 13 Artists, Gallery Soo, Seoul, Korea

Past & Present: Traditional and Contemporary Korean 'Paper Works', Muromachi Ogura, Kyoto, Japan

Salon des Artistes Français, Grand Palais, Paris, France

Inaugural Exhibition: Past and Present of Korean Contemporary Art, National Museum of Modern and Contemporary Art, Gwacheon, Korea

The Pioneering Status of Korean Contemporary Art '86, Baiksong Gallery, Seoul, Korea

1985 *Forty Years of Modern Art Exhibition, in Commemoration of Korean Independence Day*, National Museum of Modern and Contemporary Art, Deoksugung, Seoul, Korea

70 Years of Korean Western Painting, Ho-Am Art Gallery, Seoul, Korea

Minimization and Maximization, Hu Gallery; Chon Gallery, Seoul, Korea

6 Artists · Prospects of Paper, Yoon Gallery, Seoul, Korea

Paper Works by Contemporary Korean Artists, Sarah Spurgeon Gallery, Central Washington University, Washington D.C., USA

1984 *Art Today*, Tokyo Metropolitan Art Museum, Tokyo, Japan

Seoul-Paper Works '84, Kwanhoon Museum, Seoul, Korea

The Direction of Contemporary Korean Art 1970s, Taipei Fine Arts Museum, Taipei, Taiwan

Contemporary Korean Art: White Paintings by 8 Artists, French Cultural Center, Seoul, Korea

Contemporary Korean Art of the '60s: Informel and Its Surroundings, Walker Hill Art Center, Seoul, Korea

Contemporary Korean Art: The Late '70s, Korean Culture and Arts Foundation Art Center, Seoul, Korea

1983 *Prints & Drawings*, U.S.I.S, Seoul, Korea; World Print Council, San Francisco; Korean Cultural Service, Los Angeles, USA

7 Korean Artists, Yil Gallery, Taipei, Taiwan

Ecole de Seoul: New Paper Works, Spring Gallery, Taipei, Taiwan

Contemporary Korean Art: The Late 1970s, Tokyo Metropolitan Art Museum, Tokyo; Tochigi Municipal Museum of Art, Tochigi; The National Museum of Art, Osaka, Nakanoshima; Hokkaido Museum of Modern Art, Sapporo; Fukuoka City Museum, Fukuoka, Japan

The Work of 7 Contemporary Korean Artists, Jean Art Gallery, Seoul, Korea

Contemporary Korean Art, Viscontea Hall, Milan, Italy

1982 *The Art of Contemporary Paper: Korea and Japan*, National Museum of Modern and Contemporary Art, Deoksugung, Seoul, Korea; Kyoto Municipal Museum, Kyoto; Saitama Museum of Modern Art, Saitama; Kumamoto Folk Museum, Kumamoto, Japan

The Phase of Contemporary Korean Art, Kyoto Municipal Museum, Tokyo, Japan

1981 *Korean Art '81*, National Museum of Modern and Contemporary Art, Deoksugung, Seoul, Korea

Works on Paper: Drawings of Contemporary Korean Art, Dongsanbang Gallery, Seoul, Korea; Artcore Gallery, Los Angeles, USA

Drawing '81, National Museum of Modern and Contemporary Art, Deoksugung, Seoul, Korea

1981-69 *Korean National Art Exhibition*, National Museum of Modern and Contemporary Art, Deoksugung, Seoul, Korea

1980 *Korean Prints and Drawing*, National Museum of Modern and Contemporary Art, Deoksugung, Seoul, Korea

37 Contemporary Artists, Kwanhoon Museum, Seoul, Korea

1979	*Korean Arts: Unique Methods of Today Part II*, Korean Culture and Arts Foundation Art Center, Seoul, Korea
1978	*The Trend for the Past 20 Years of Contemporary Art*, National Museum of Modern and Contemporary Art, Deoksugung, Seoul, Korea
1977	*Korean Contemporary Painting*, National Museum of Modern and Contemporary Art, Deoksugung, Seoul, Korea
	Korea: Facet of Contemporary Art, Tokyo Central Art Museum, Tokyo, Japan
	Korean Contemporary Paintings, National Museum of History, Taipei, Taiwan
1974	*The 3rd India Triennale*, New Delhi, India
	The 10th Asian Contemporary Art Exhibition, Tokyo, Japan
1973	*Korean Contemporary Art 1957-1972 Part I: Abstraction-Situation*, Myongdong Gallery, Seoul, Korea
	Korean Contemporary Art '73, Downtown Gallery, Hawaii, USA
1972	*Korean Contemporary Art*, Gallery Harugu, Tokyo, Japan
1970	*The 1st Grand Prize Exhibition of Korean Art*, National Museum of Modern and Contemporary Art, Gyeongbokgung, Seoul, Korea
1969	*The 1st Pistoia International Paintings Biennale*, Pistoia, Italy
	The 1st Cannes International Paintings Festival, Cannes, France
1968	*The 12th Korean National Art Exhibition*, Gyeongbokgung Museum, Seoul, Korea
	Korean Contemporary Paintings, Tokyo National Museum of Modern Art, Tokyo, Japan
1968-57	*Contemporary Art Exhibit*, Deoksugung Museum; Gyeongbokgung Museum, Seoul, Korea
1965	*The 8th Biennial de Sao Paulo*, Sao Paulo, Brazil
1964	*The 2nd Actuelle Group Show*, Gyeongbokgung Museum, Seoul, Korea
1963	*The 2nd Cultural Freedom Invitational*, Korean Information Center Gallery, Seoul, Korea
1962	*The 1st Actuelle Group Show*, Korean Information Center Gallery, Seoul, Korea
	The 1st Saigon International Biennale, Saigon, Vietnam
1961	*The 2nd Biennale de Paris*, Paris, France
	International Freedom, Tokyo National Stadium Gallery, Tokyo, Japan
1958	*Contemporary Korean Artists*, World House Gallery, New York, USA
1957	*Invitational Exhibition of Cultural Freedom*, Asia Foundation, Seoul, Korea
1956-53	*Korean National Art Exhibition*, Gyeongbokgung Museum, Seoul, Korea
1954	*Holy Artist Association Exhibition*, Midopa Gallery, Seoul, Korea
1950	*Graduate Exhibition*, College of Fine Arts, Seoul National University, Seoul, Korea

Selected Awards

1993	The Order of Korean National Art Merit, Korea
1987	Grand Prize for Art Section, The 13th Joong Ang Cultural Grand Prize, Korea
1980	Invited Artist Award, The 29th Korean National Art Exhibition, Korea
1962	Bronze Prize and Esso Prize, The 1st Saigon International Biennale, Vietnam
1955	Special Prize, The 4th Korean National Art Exhibition, Korea
1953	Special Prize, The 2nd Korean National Art Exhibition, Korea
1950	President Prize, Graduate Exhibition by College of Fine Arts, Seoul National University, Korea

Selected Collections

National Museum of Modern and Contemporary Art, Korea
Seoul Museum of Art, Korea
Busan Museum of Art, Korea
Daejeon Museum of Art, Korea
Leeum Museum of Art, Korea
Art Center Nabi, Korea
Wooyang Museum of Contemporary Art, Korea
Youngeun Museum of Contemporary Art, Korea
Seoul National University Museum of Art, Korea
Korea University Museum, Korea
Ewha Womans University Museum, Korea
Tokyo Metropolitan Art Museum, Japan
Mie Prefectural Art Museum, Japan
Shimonoseki City Art Museum, Japan
Hiroshima City Museum of Contemporary Art, Japan
M+, Hong Kong
Nepal Academy of Fine Arts, Nepal
Guggenheim Abu Dhabi, UAE

List of Works

01.
Meditation 20112, 2000
Tak fiber on cotton
259 x 194 cm

02.
Meditation 20301, 2000
Tak fiber on cotton
194 x 259 cm

03.
Meditation 94705, 1994
Tak fiber on cotton
220 x 140 cm

04.
Meditation 22806, 2002
Tak fiber on cotton
130 x 162 cm

05.
Meditation 981005, 1998
Tak fiber on cotton
194 x 259 cm

06.
Meditation 211204, 2001
Tak fiber on cotton
194 x 259 cm

07.
Meditation 23904, 2003
Tak fiber on cotton
180 x 90 cm

08.
Meditation 23901, 2003
Tak fiber on cotton
180 x 90 cm

09.
Meditation 91101, 1991
Mixed media with Korean paper
110 x 200 cm

10.
Meditation 91077, 1991
Tak fiber on canvas
140 x 240 cm

11.
Meditation 91216, 1991
Tak fiber on canvas
140 x 240 cm

12.
Meditation 97620, 1997
Tak fiber on cotton
97 x 130.3 cm

13.
Meditation 22903, 2002
Tak fiber on cotton
130 x 162 cm

14.
Tak 88002, 1988
Tak fiber on cotton
97.2 x 130.5 cm

15.
Untitled, ca. 1991
Tak fiber on canvas
73 x 91 cm

16.
Untitled, ca. 1991
Tak fiber on canvas
92 x 116 cm

17.
Meditation 91107, 1991
Mixed media with Korean paper
110 x 200 cm

18.
Meditation 20810, 2000
Tak fiber on cotton
60.6 x 72.7 cm

19.
Meditation 21804, 2001
Tak fiber on cotton
60.6 x 72.7 cm

20.
Meditation 21805, 2001
Tak fiber on cotton
60.6 x 72.7 cm

21.
Meditation 94202, 1994
Tak fiber on canvas
200 x 100 cm

22.
Meditation 94203, 1994
Tak fiber on canvas
200 x 100 cm

23.
Meditation 94201, 1994
Tak fiber on canvas
200 x 100 cm

24.
Meditation 21206, 2001
Tak fiber on cotton
130 x 162 cm

25.
Tak 88001, 1988
Tak fiber on cotton
97.2 x 130.5 cm

26.
Tak 89033, 1989
Tak fiber on cotton
120 x 210 cm

27.
Meditation 971041, 1997
Tak fiber on cotton
100 x 130.3 cm

28.
Meditation 98705, 1998
Tak fiber on cotton
80 x 80 cm

29.
Meditation 98702, 1998
Tak fiber on cotton
80 x 80 cm

30.
Meditation 231004, 2003
Tak fiber on cotton
115 x 115 cm

31.
Meditation 231103, 2003
Tak fiber on cotton
115 x 115 cm

32.
Meditation 23704, 2003
Tak fiber on cotton
91 x 116.7 cm

33.
Meditation 97621, 1997
Tak fiber on cotton
97 x 130.3 cm

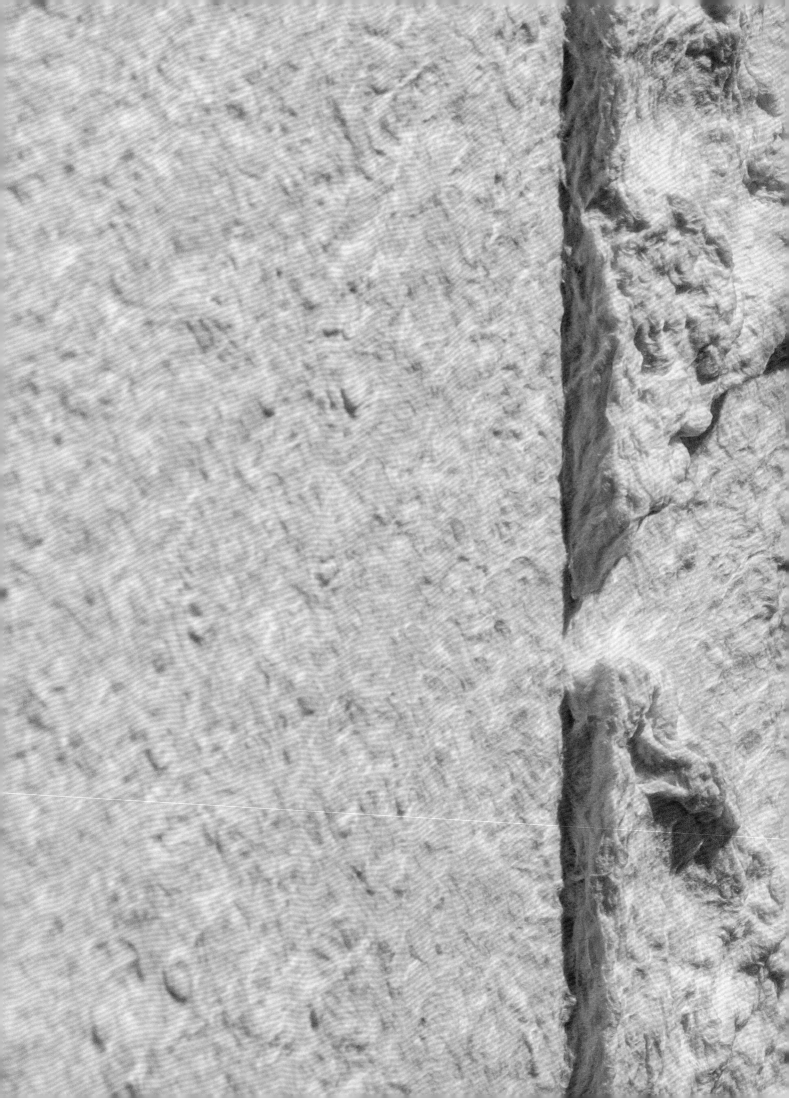

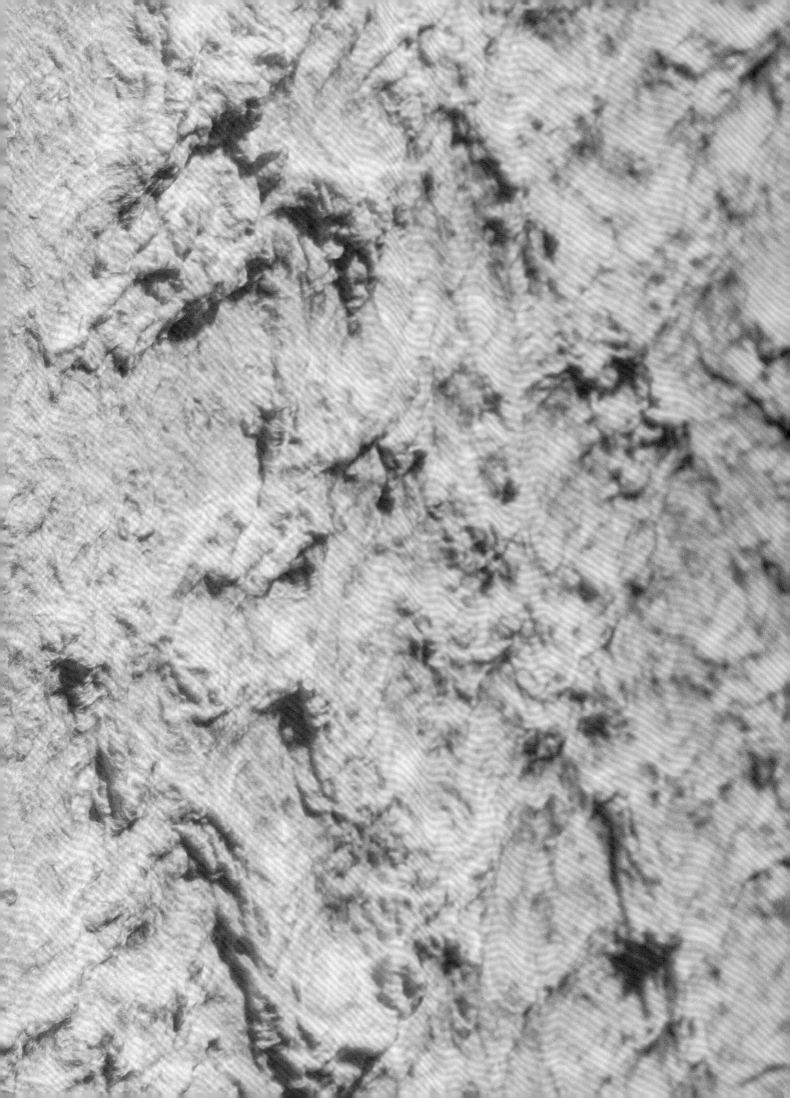

CHUNG CHANG-SUP
MIND IN MATTER
정창섭, 물(物)심(心)

Publisher		PKM BOOKS	피케이엠북스
Organizer		The Estate of Chung Chang-Sup	정창섭 에스테이트
		PKM Gallery	피케이엠갤러리
Image Copyright		The Estate of Chung Chang-Sup	정창섭 에스테이트
Text Copyright		The Estate of Chung Chang-Sup	정창섭 에스테이트
		Lee Chungwoo (Lim Michael)	이정우 (임근준)
Translation	pp. 7-9	Park Chaewon	박채원
	pp. 11-18	Park Jaeyong	박재용
Editing		Park Kyung-mee	박경미
		Kwon Youngjin	권영진
Copy-editing	Korean	Jang Yeran	장예란
		Youjung Kim	김유정
	English	Moon Hae Rin	문혜린
Photography	work images	Jeon Byung Cheol	전병철
	detailed work images & installation views	Choi Yong Joon	최용준
Design		Yoo Sukyung	유수경
Printing		Graphic Korea	그래픽코리아

This publication accompanies with *Chung Chang-Sup, Mind in Matter*, the solo exhibition of Chung Chang-Sup at PKM Gallery from August 25 to October 29, 2022.

이 책은 2022년 8월 25일부터 10월 29일까지 피케이엠갤러리에서 개최되는 정창섭 화백 개인전《정창섭, 물(物)심(心)》과 연계하여 발간되었습니다.

PKM BOOKS

74-9, Yulgok-ro 3-gil, Jongno-gu, Seoul, Korea
+82 2 734 9467

ISBN 979-11-976081-5-5 (03650)
₩ 60,000